Schirmer's Visual Library

Elvis Presley—The

Numerous singers, guitarists and
popularity since the first decade of ..., but only one
has become immortal: Elvis Presley (1935–1977). His shows
were exhilarating, revolutionary, erotic and pure dynamite
before he was subjected to army discipline and the Hollywood
"cosmeticians" who turned this precious raw diamond into an
industrial product.

In his early years, 1954–1960, Elvis still had the unrestrained
power of a naive, exceedingly charming Southern lad who slow-
ly lost his innocence. Yet he was still far removed from exempli-
fying the cultural values of the Nixon era or from doing what
Lester Bangs faulted the later megastar for: "Elvis was into
marketing boredom when Andy Warhol was still doing shoe
ads." In these early years, Elvis was the man who introduced
sexual fantasy to the prude and allegedly "virtuous" entertain-
ment world in America, manifesting with a few gyrations the
secret desires of millions of teenagers and becoming the true
founder of the youth revolt—an idol and rebel who struck the
hearts of his fans like lightning, creating a fervent blaze that was
never to be quenched.

The introduction is by the legendary music critic Lester
Bangs (1949–1982), whose brilliant essays—in magazines like
Rolling Stone, Creem, The Village Voice—mark him as one of the
most original and influential pop critics of the seventies.

120 pages, 64 duotone and color illustrations

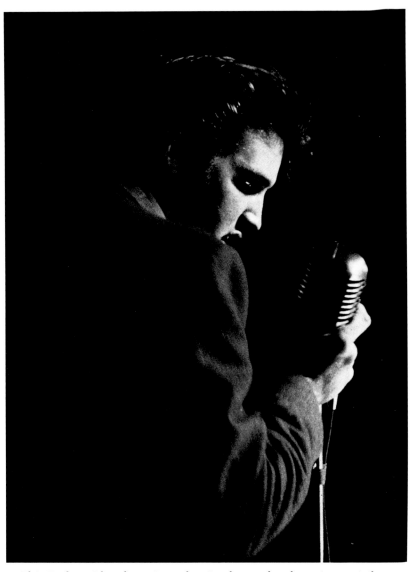

Elvis Presley, with a firm grip on the microphone and audience, in a typical pose at one of his early concerts, in Florida, 1956. Photo by Jay B. Leviton.

Elvis Presley

The Rebel Years

Photographed during the fantastic years
of the King of Rock'n Roll 1954–1960

With a text by Lester Bangs

W. W. Norton & Company
New York · London

For Angelika Döttinger

The essay by Lester Bangs, *Where Were You When Elvis Died,*
first appeared on August 29, 1977, in *The Village Voice.*
Picture captions by Daniel Dreier.
Translations by Paul Kremmel.

Reproductions: O. R. T. Kirchner GmbH, Berlin
Typesetting: Typ-O-Graph, Munich
Printed and bound in Italy

ISBN 0-393-31625-4

A Schirmer / Mosel Production
Published by W. W. Norton & Company
New York · London

"Elvis is my man."

Janis Joplin

"Two thousand years from now they'll still be hearing about Elvis Presley."

Wolfman Jack

"Nothing really affected me until Elvis."

John Lennon

Where Were You When Elvis Died?

Where were *you* when Elvis died? What were you doing, and what did it give you an excuse to do with the rest of your day? That's what we'll be talking about in the future when we remember this grand occasion. Like Pearl Harbor or JFK's assassination, it boiled down to individual reminiscences, which is perhaps as it should be, because in spite of his greatness, etc., etc., Elvis had left us each as alone as he was; I mean, he wasn't exactly a Man of the People anymore, if you get my drift. If you don't I will drift even firther, away from Elvis into the contemplation of why all our public heroes seem to reinforce our own solitude.

The ultimate sin of any performer is contempt for the audience. Those who indulge in it will ultimately reap the scorn of those they've dumped on, whether they live forever like Andy Paleface Warhol or die fashionably early like Lenny Bruce, Jimi Hendrix, Janis Joplin, Jim Morrison, Charlie Parker, Billie Holiday. The two things that distinguish those deaths from Elvis's (he and they having drug habits vaguely in common) were that all of them died on the outside looking in and none of them took their audience for granted. Which is why it's just a little bit harder for me to see Elvis as a tragic figure; I see him as being more like the Pentagon, a giant armored institution nobody knows anything about except that its power is legendary.

Obviously we all liked Elvis better than the Pentagon, but look

at what a paltry statement that is. In the end, Elvis's scorn for his fans as manifested in "new" albums full of previously released material and one new song to make sure all us suckers would buy it was mirrored in the scorn we all secretly or not so secretly felt for a man came closer to godhood than Carlos Castaneda until military conscription tamed and revealed him for the dumb lackey he always was in the first place. And ever since, for almost two decades now, we've been waiting for him to get wild again, fools that we are, and he probably knew better than any of us in his heart of hearts that it was never gonna happen, his heart of hearts so obviously not being our collective heart of hearts, he being so obviously just some poor dumb Southern boy with a Big Daddy manager to screen the world for him and filter out anything which might erode his status as big strapping baby bringing home the bucks, and finally being sort of perversely celebrated at least by rock critics for his utter contempt for whoever cared about him.

And Elvis was perverse; only a true pervert could put out something like *Having Fun with Elvis On Stage,* that album released three or so years back which consisted *entirely* of between-song onstage patter so redundant it would make both Willy Burroughs and Gert Stein blush. Elvis was into marketing boredom when Andy Warhol was still doing shoe ads, but Elvis's sin was his failure to realize that his fans were not perverse—they loved him without qualification, no matter what he dumped on them they loyally lapped it up, and that's why I feel a hell of a lot sorrier for all those poor jerks than for Elvis himself. I mean, who's left they can stand all night in the rain for? Nobody, and the true tragedy is the tragedy of an entire generation which refuses to give up its adolescence even as it feels its menopausal paunch begin to blossom and its hair

recede over the horizon—along with Elvis and everything else they once thought they believed in Will they care in five years what he's been doing for the last twenty?

Sure Elvis's death is a relatively minor ironic variant on the future-shock mazurka, and perhaps the most significant thing about Elvis's exit is that the entire history of the seventies has been retreads and brutal demystification; three of Elvis's ex-bodyguards recently got together with this hacker from the New York *Post* and whipped up a book which dosed us with all the dirt we'd yearned for for so long. Elvis was the last of our sacred cows to be publicly mutilated; everybody knows Keith Richard likes his junk, but when Elvis went onstage in a stupor nobody breathed a hint of "Quaalude. . . ." In a way, this was both good and bad, good becuase Elvis wasn't encouraging other people to think it was cool to be a walking *Physicians' Desk Reference,* bad because Elvis stood for that Nixonian Secrecy-as-Virtue which was passed off as the essence of Americanism for a few years there. In a sense he could be seen not only as a phenomenon that exploded in the fifties to help shape the psychic jailbreak of the sixties but ultimately as a perfect cultural expression of what the Nixon years were all about. Not that he prospered more then, but that his passion for the privacy of potentates allowed him to get away with almost literal murder, certainly with the symbolic rape of his fans, meaning that we might all do better to think about waving good-bye with one upraised finger.

I got the news of Elvis's death while drinking beer with a friend and fellow music journalist on his fire escape on 21st Street in Chelsea. Chelsea is a good neighborhood; in spite of the fact that the insane woman who lives upstairs keeps him awake all night every night with her rants at no one, my friend stays there

because he likes the sense of community within diversity in that neighborhood: old-time card-carrying Communists live in his building alongside people of every persuasion popularly lumped as "ethnic." When we heard about Elvis we knew a wake was in order, so I went out to the deli for a case of beer. As I left the building I passed some Latin guys hanging out by the front door. "Heard the news? Elvis is dead!" I told them. They looked at me with contemptuous indifference. *So what.* Maybe if I had told them Donna Summer was dead I might have gotten a recation; I do recall walking in this neighborhood wearing a T-shirt that said "Disco Sucks" with a vast unamused muttering in my wake, which only goes to show that not for everyone was Elvis the still-reigning King of Rock 'n' Roll, in fact not for everyone is rock 'n' roll the still-reigning music. By now, each citizen has found his own little obsessive corner to blast his brains in: as the sixties were supremely narcissistic, solipsism's what the seventies have been about, and nowhere is this better demonstrated than in the world of "pop" music. And Elvis may have been the greatest solipsist of all.

I asked for two six-packs at the deli and told the guy behind the counter the news. He looked fifty years old, greying, big belly, life still in his eyes, and he said: "Shit, that's too bad. I guess our only hope now is if the Beatles get back together."
Fifty years old.

I told him I thought that would be the biggest anticlimax in history and that the best thing the Stones could do now would be to break up and spare us all further embarrassments.

He laughed, and gave me directions to a meat market down the street. There I asked the counterman the same question I had been asking everyone. He was in his fifties too, and he said "You know what? I don't *care* that bastard's dead. I took my

12

wife to see him in Vegas in '73, we paid fourteen dollars a ticket, and he came out and sang for twenty minutes. Then he fell down. Then he stood up and sang a couple more songs, then he fell down again. Finally he said, 'Well, shit, I might as well sing sitting as standing.' So he quatted on the stage and asked the band what song they wanted to do next, but before they could answer he was complaining about the lights. 'They're too bright,' he says. 'They hurt my eyes. Put 'em out or I don't sing a note.' So they do. So me and my wife are sitting in total blackness listening to this guy sing songs we knew and loved, and I ain't just talking about his old goddam songs, but he totally *butchered* all of 'em. Fuck him. I'm not saying I'm glad he's dead, but I know one thing: I got taken when I went to see Elvis Presley."

I got taken too the one time I saw Elvis, but in a totally different way. It was the autumn of 1971, and two tickets to an Elvis show turned up at the offices of *Creem* magazine, where I was then employed. It was decided that those staff members who had never had the privilege of witnessing Elvis should get the tickets, which was how me and art director Charlie Auringer ended up in nearly the front row of the biggest arena in Detroit. Earlier Charlie had said, "Do you realize how much we could get if we sold these fucking things?" I didn't, but how precious they were became totally clear the instant Elvis sauntered onto the stage. He was the only male performer I have ever seen to whom I responded sexually; it wasn't real arousal, rather an erection of the heart, when I looked at him I went mad with desire and envy and worship and self-projection. I mean, Mick Jagger, whom I saw as far back as 1964 and twice in '65, never even came close.

There was Elvis, dressed up in this ridiculous white suit which

looked like some studded Arthurian castle, and he was too fat, and the buckle on his belt was as big as your head except that your head is not made of solid gold, and any lesser man would have been the spittin' image of a Neil Diamond damfool in such a getup, but on Elvis it fit. What didn't? No matter how lousy his records ever got, no matter how intently he pursued mediocrity, there was still some hint, some flash left over from the days when ... well, I wasn't there, so I won't presume to comment. But I will say this: Elvis Presley was the man who brought overt blatant vulgar sexual frenzy to the popular arts in America (and thereby to the nation itself, since putting "popular arts" and "America" in the same sentence seems almost redundant). It has been said that he was the first white to sing like a black person, which is untrue in terms of hard facts but totally true in terms of cultural impact. But what's more crucial is that when Elvis started wiggling his hips and Ed Sullivan refused to show ist, the entire country went into a paroxysm of sexual frustration leading to abiding discontent which culminated in the explosion of psychedelic-militant folklore which was the sixties.

I mean, don't tell me about Lenny Bruce, man—Lenny Bruce said dirty words in public and obtained a kind of consensual martyrdom. Plus which Lenny Bruce was hip, too goddam hip if you ask me, which was his undoing, whereas Elvis was not hip at all, Elvis was a goddam truck driver who worshipped his mother and would never say shit or fuck around her, and Elvis alerted America to the fact that it had a groin with imperatives that had been stifled. Lenny Bruce demonstrated how far you could push a society as repressed as ours and how much you could get away with, but Elvis kicked "How Much Is That Doggie in the Window" *out* the window and replaced it with "Let's

fuck". The rest of us are still reeling from the impact. Sexual chaos reigns currently, but out of chaos may flow true understanding and harmony, and either way Elvis almost singlehandedly opened the floodgates. That night in Detroit, a night I will never forget, he had but to ever so slightly move one shoulder muscle, not even a shrug, and the girls in the gallery hit by its ray screamed, fainted, howled in heat. Literally, every time this man moved any part of his body the slightest centimeter, tens or tens of thousands of people went berserk. Not Sinatra, not Jagger, not the Beatles, nobody you can come up with ever elicited such hysteria among so many. And this after a decade and a half of crappy records, of making a point of not trying.

If love truly is going out of fashion forever, which I do not believe, then along with our nurtured indifference to each other will be an even more contemptuous indifference to each other's objects of reverence. I thought it was Iggy Stooge, you thought it was Joni Mitchell or whoever else seemed to speak for your own private, entirely circumscribed situation's many pains and few ecstasies. We will continue to fragment in this manner, becuase solipsism holds all the cards at present; it is a king whose domain engulfs even Elvis's. But I can guarantee you one thing: we will never again agree on anything as we agreed on Elvis. So I won't bother saying good-bye to his corpse. I will say good-bye to you.

<div align="right">Village Voice, 29 August 1977</div>

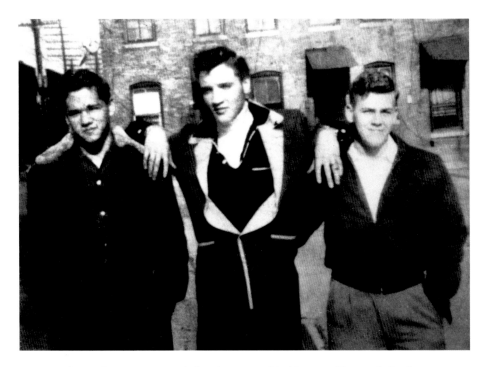

Above: Elvis at sixteen with friends in Memphis, Tennessee. He attends L. C. Humes High School where he graduates in 1953. The guitar his mother gave him for his eleventh birthday, the gospel music of his church and the ceaseless flow of country music from the local radio stations are the teenager's primary sources of inspiration.

Elvis with his friend, Jimmy Velvet, who amassed a large collection of Elvis memorabilia after the star's death and founded the Elvis Presley Museum in Memphis.

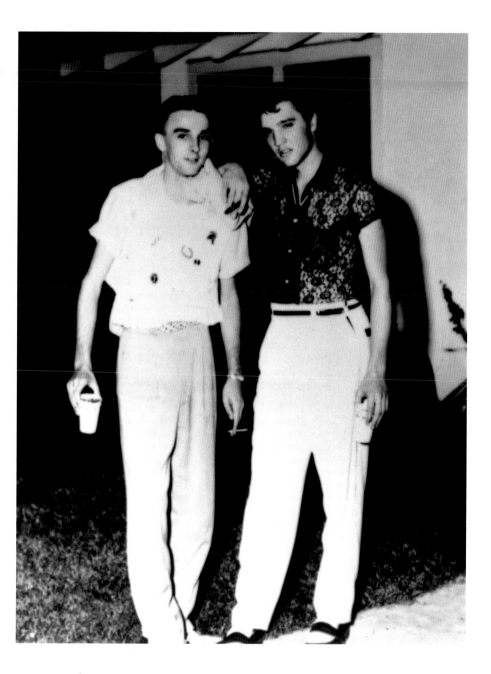

His first recording was an acetate disc *(My Happiness and That's When Your Heartaches Begin)* that he cut himself in the late summer of 1953 as a birthday present, as he maintained, for his much-revered mother; in the summer of 1954 his career took off.

On July 5, 1954, Elvis, employed as a truck driver, records *That's All Right (Mama)* with his friends Bill Black (bass) and Scotty Moore (guitar) at Sam Phillip's Sun Studio in Memphis. But in actual fact, since the beginning of 1953, Elvis had made periodic attempts to catch Sam Phillip's attention with demo tapes. He succeeded with his July 5 recording. On July 7 the local radio station played the recording during on its Saturday evening music program "Red Hot and Blue." The disc jockey was swamped by calls and replayed the record thirteen times. The success was so great that the station called him in for an interview. The listeners' instincts were unmistakable and can easily be tested by relistening to this recording today (available as an LP—*The Complete Sun Sessions*—containing all the takes Elvis did for Sun Records). The following Monday, Elvis, Scotty Moore and Bill Black formed a group, the Blue Moon Boys. A week later the record *That's All Right (Mama)* with *Blue Moon of Kentucky* on the flip side was on the market (Sun Records 209). In the following twelve months, Elvis and his group played in towns and communities in the South and Southwest. Elvis was initially announced as "Hillbilly Cat and the Blue Moon Boys." From performance to performance, the storm of enthusiasm grew to gale proportions, then to an unparalleled mass hysteria. Like a bolt from the blue, Elvis struck America and the world. *Heartbreak Hotel,* recorded eighteen months later in January 1956, became his first international hit.

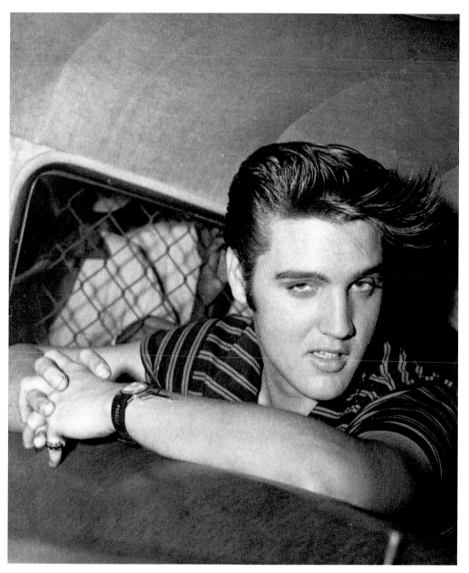

The crown of the future King of Rock 'n' Roll is his magnificent head of hair which went into action as soon as the music started up.

Initially, the young star's hair looks more like it was gone over by a lawn mower. The picture shows Elvis in his first publicity shot taken shortly after the success of That's All Right (Mama) *in 1954. Traces of the truck driver milieu are as evident as the proletarian charm of our hero, whom an announcer in October 1954 could still introduce as "the poor man's Liberace."*

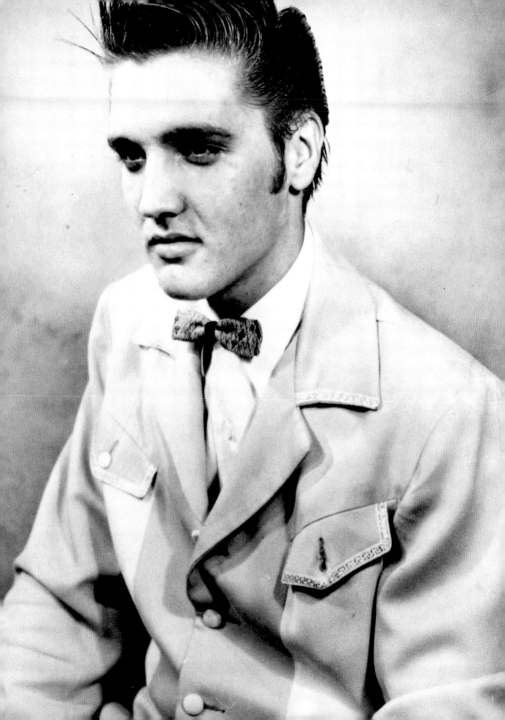

In fifties America, where segregation was still particularly strong in Tennessee, no one had heard a white man sing this way. The epithet "Hillbilly Cat" meant "white Negro."

Right: Elvis in a typical pose: A modern troubadour fresh from the comic strips with a rough, backwoods charm. His songs are as explosive and vulgar as they are loving and poignant; their sexual overtones are unmistakable. Elvis conveys all this with the innocent pose of the boy next door.

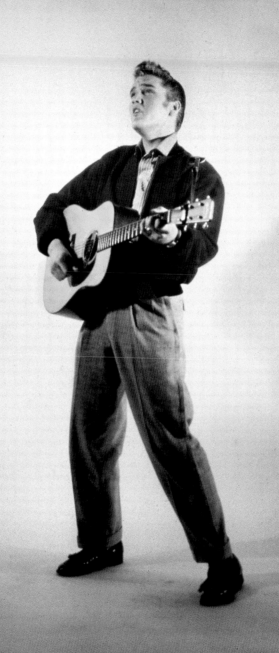

Following pages: "He was the only male performer I have ever seen to whom I responded sexually; it wasn't real arousal, rather an erection of the heart, when I looked at him I went mad with desire and envy and worship and self-projection." This was how Lester Bangs described an Elvis Presley appearance in 1971. Imagine how strong the sensation must have been in the magical years 1955 and 1956! The following sequence of photos conveys a visual impression of those years. Musically, the blending of rhythm 'n' blues with elements of country music led to an epoch-making innovation: rock 'n' roll. Listening to Elvis's own words, it's not immediately clear if it's a new departure in music or some kind of collective, impulsive movement: "Rock 'n' roll music, if you like it and if you feel it, you can't help but move to it. That's what happens to me. I can't help it."

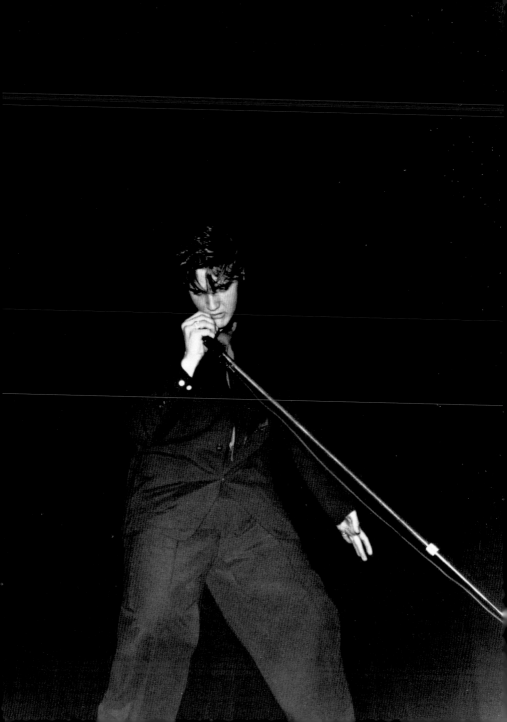

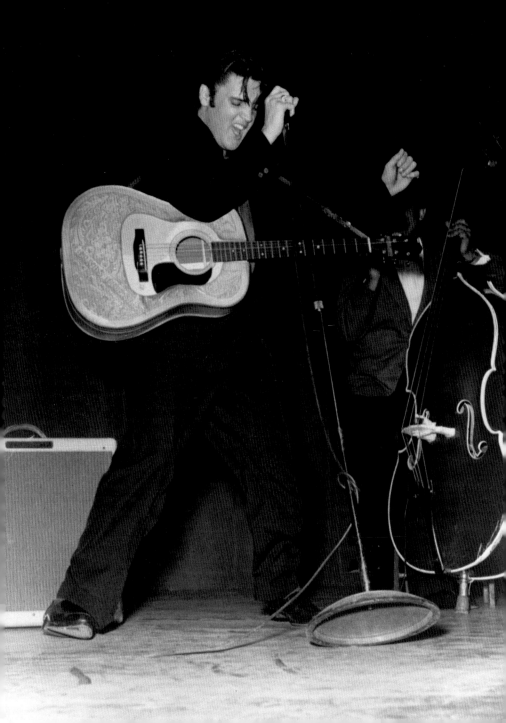

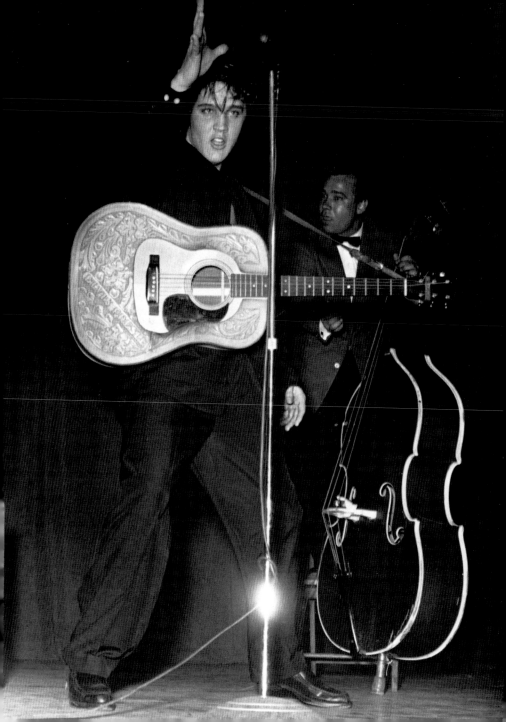

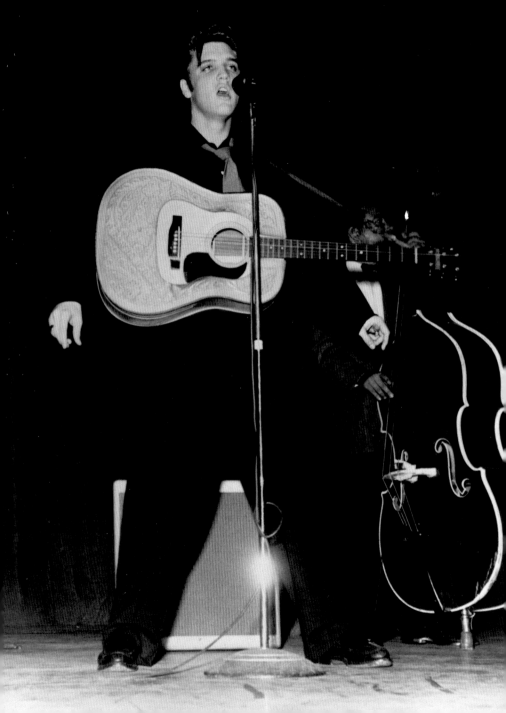

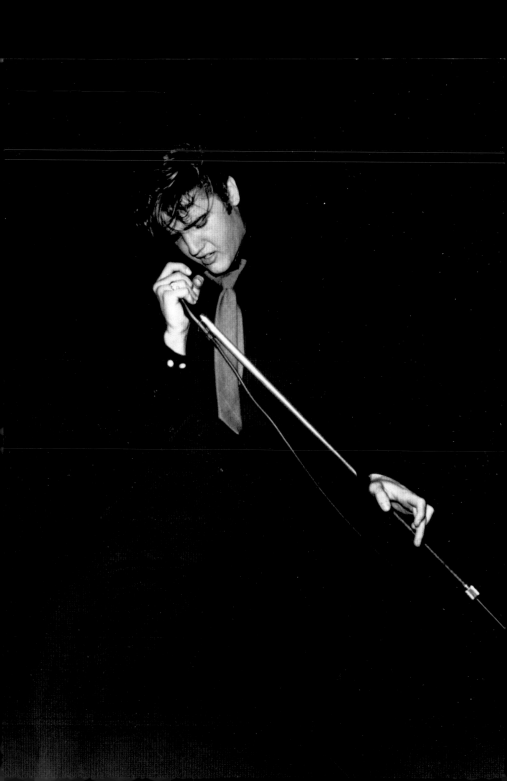

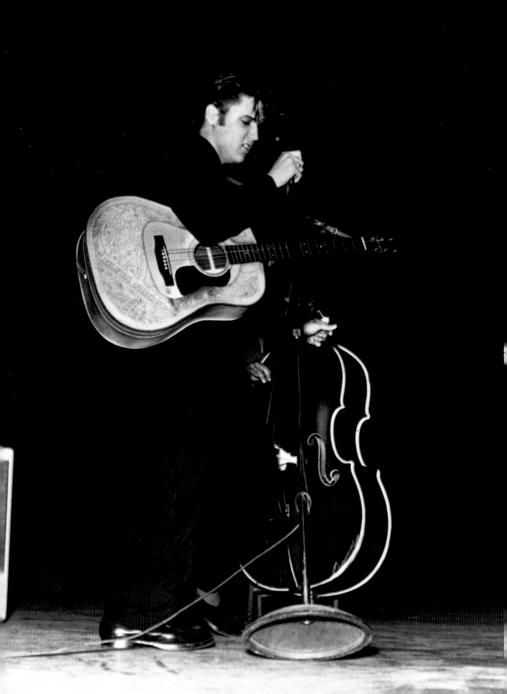

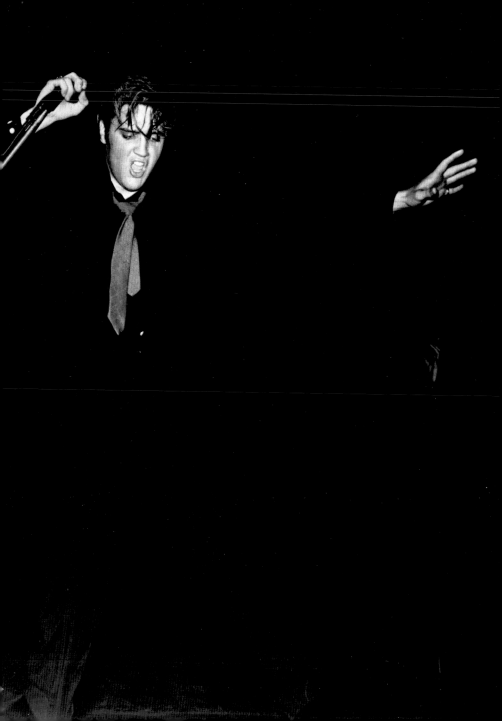

Quoting Lester Bangs once again: "Elvis Presley was the man who brought overt blatant vulgar sexual frenzy to the popular arts in America (and thereby to the nation itself . . .)." Elvis's own reaction to the excitement he ignited was cool and self-confident. After a performance in Jacksonville (1955) he made the ironic and provoking remark: "Girls, I'll see you all backstage." This predictably led to general pandemonium. Fourteen thousand girls went wild, and Elvis had most of his clothes torn off. This didn't seem to bother the young "King" who made it a strategic part of his spectacular performances. "I don't mind if the fans rip the shirt from my back, they put it there in the first place." This was Elvis's description of the unique give-and-take that soon set in between the idol and his fans.

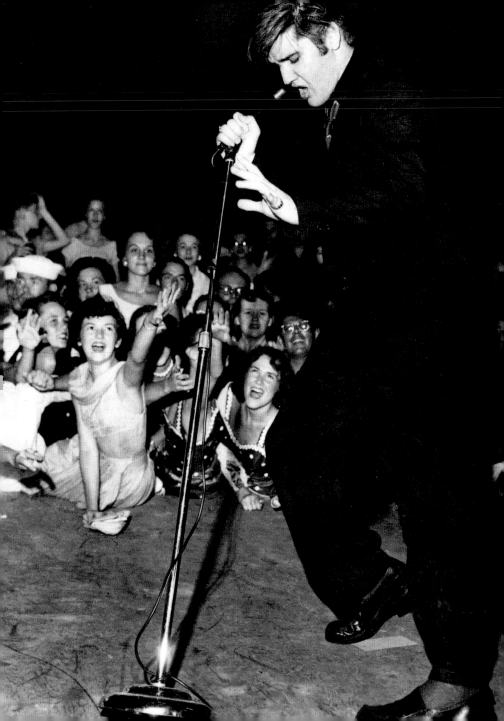

Right: A UPI photograph of June 22, 1956, shows Elvis in a typical pose: one hand gripping the microphone and the other with its pointed finger seeking contact with the audience. His bouncing legs and the electric cable show that both the medium and its equipment are charged—the message can flow. The elegance of the pose is reminiscent of Cassius Clay's later appearances.

Following pages: Before and after every concert the same hour-long ritual: autographs for his fans, 1956.

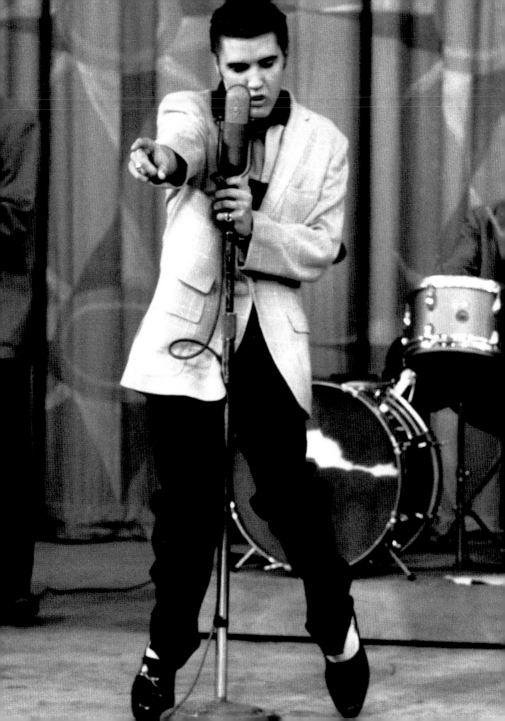

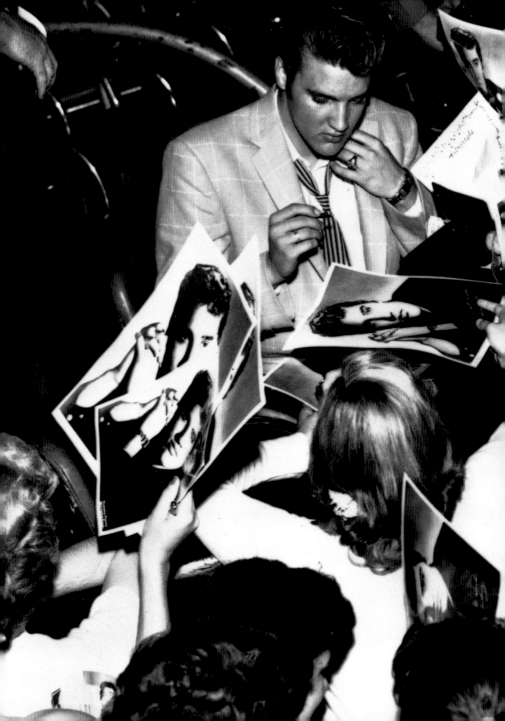

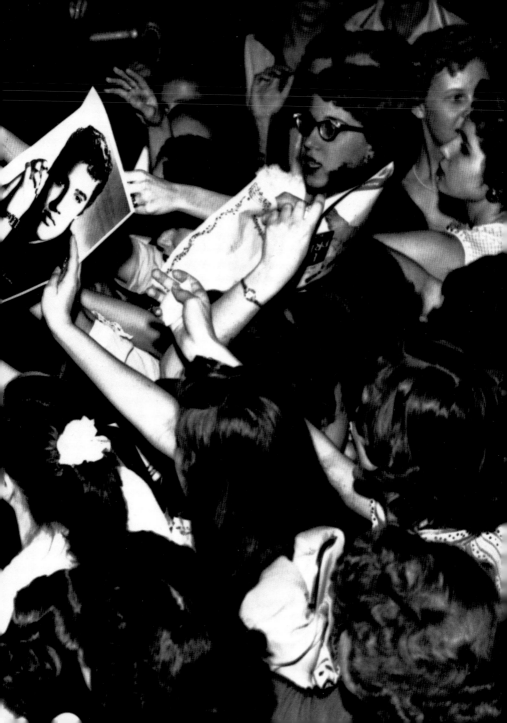

Right and following pages: The publicity shot that Elvis is liberally giving away on the previous pages was taken, as were the two following photos, in 1955 in the Memphis studio of former Hollywood photographer William Speer. The publicity photo chosen from this session (right) shows an untypically introverted Elvis posing as a Latin lover. No wonder American newspapers were soon referring to him as the "singing Valentino." William Speer, who persuaded Elvis to take off his shirt for these shots, was reminded of the young Burt Lancaster.

Following pages: The young Elvis is clearly aware of his physical appeal and poses narcissistically for the camera. Knowing that mirthfulness undermines any erotic aura, he presents himself at such photo sessions—professional that he is—in a pensive, serious and dreamy manner.

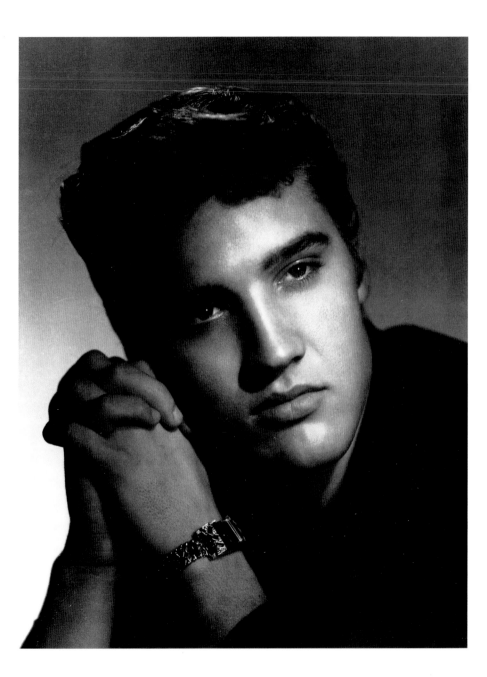

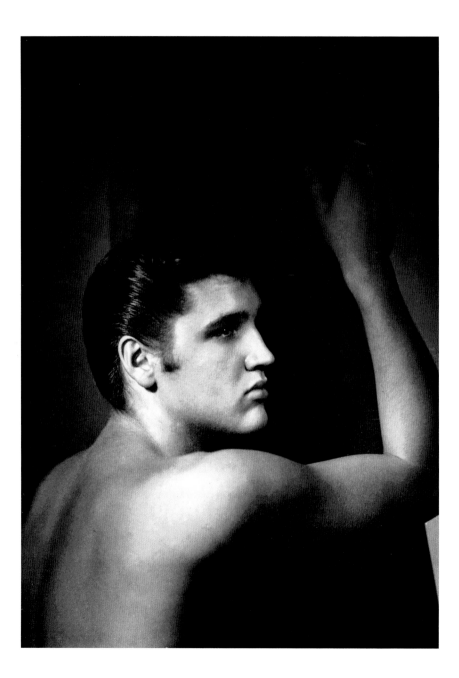

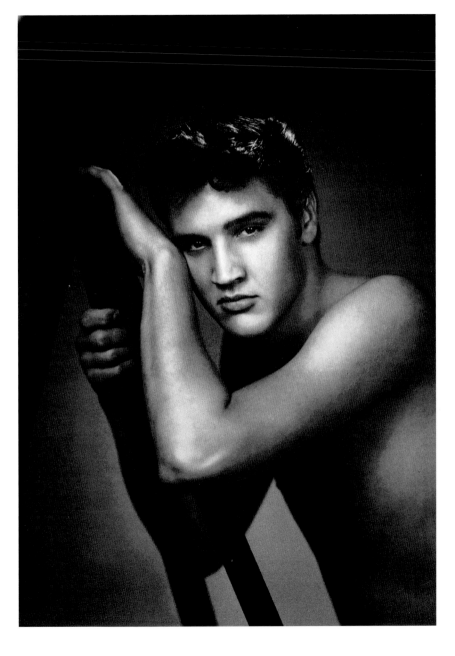

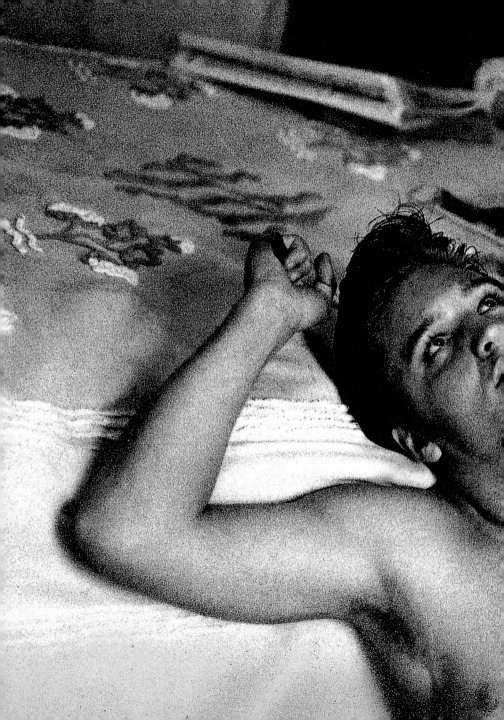

The year 1956 brought not only the major breakthrough; it was the very pinnacle of a gigantic career. In January Elvis recorded *Heartbreak Hotel,* his first international hit. *Hound Dog, Don't Be Cruel* and *Love Me Tender* followed the same year. On January 28 he made his first national television performance on the Dorsey Brothers' "Stage Show." Further appearances on "The Milton Berle Show" (April 3 and June 5, 1956) and on "The Ed Sullivan Show" (September 9 and October 28, 1956) transformed Elvis into a national institution. The country's moral authorities were deeply unsettled at the erotically charged entertainer's invasion of living rooms and the fact that he was obviously lowering moral inhibitions. The *New York Times'* TV critic Jack Gould unwittingly discovered a positive aspect of this disturbing event when he wrote: "In the long run, perhaps Presley will do everyone a favor by pointing up the need for earlier sex education." How true!

On April 1, 1956, a Sunday, screen tests began in Hollywood. The first Elvis Presley film, *Love Me Tender,* had its premiere on November 15. The movie was launched nationwide with five hundred copies (two to three hundred was normal) and recouped production costs within three days.

Right: Elvis during his first America-wide TV appearance on the Dorsey Brothers' "Stage Show." Even decked out in a tuxedo, Elvis's charm is not subdued. The critics describe his impact on the public as overwhelming and hypnotic.

Following pages: Elvis at the swimming pool of his Las Vegas hotel (right). In April 1956 he started a disastrous two-week engagement at the New Frontier Hotel in Las Vegas. His rock 'n' roll numbers failed to excite the largely middle-aged, middle-class audience.

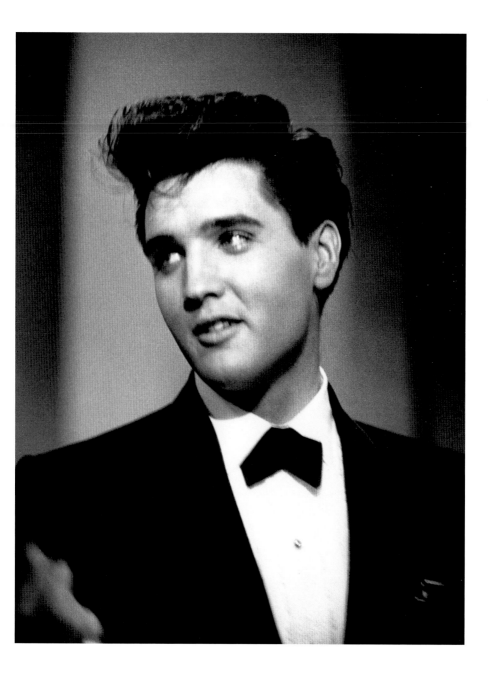

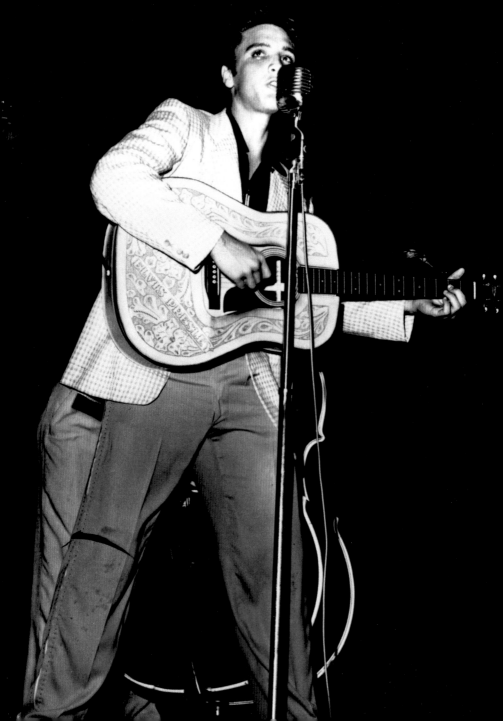

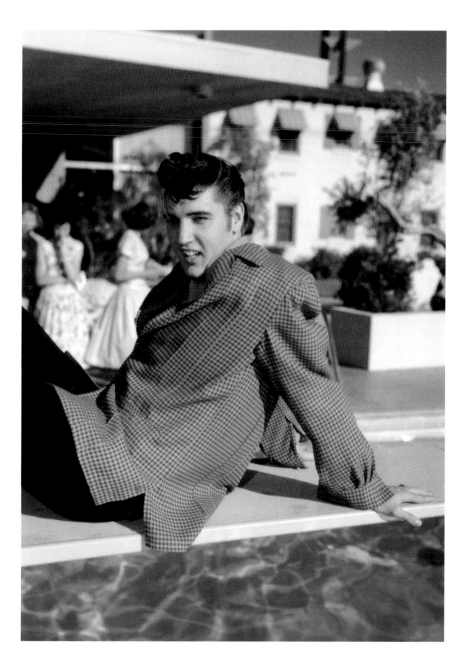

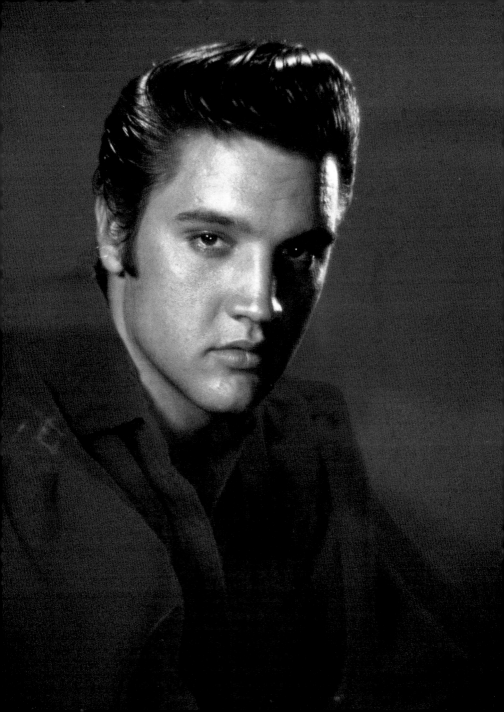

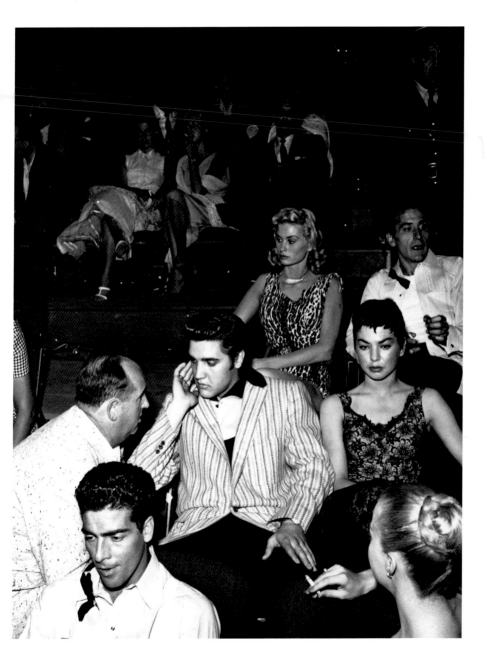

Previous pages: Left, Publicity photograph. Right, Elvis Presley with Colonel Parker, his manager since mid-1955, during a rehearsal for his appearance on "The Milton Berle Show" on June 5, 1956. Behind him in a leopardskin dress is the second guest star, actress Irish McCalla.

Right: The picture confirms William Speer's impression that he looks like the young Burt Lancaster.

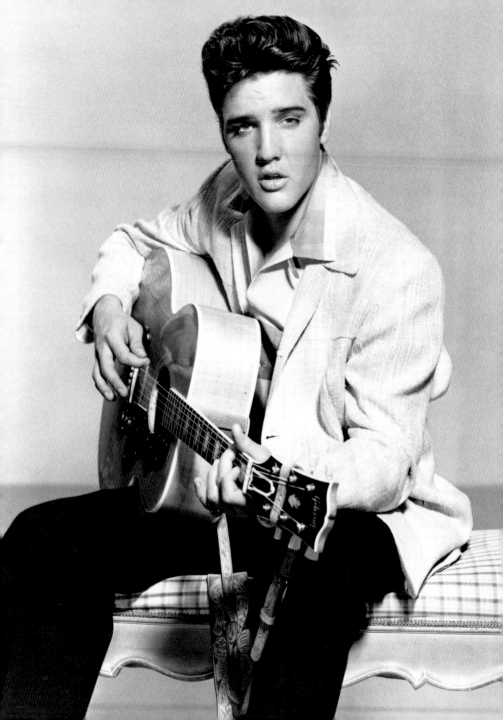

A publicity photo showing Elvis's classical profile. His facial features are indeed finely proportioned; the frequent comparison with Greek sculpture is not entirely unrealistic.

Following pages: After his sensational TV appearance on "The Ed Sullivan Show," which was viewed by nearly sixty million Americans, Elvis returned to his home town, Tupelo, Mississippi, to give two open-air concerts at the Mississippi-Alabama Fair and Dairy Show. His homecoming was a complete triumph. Between the matinee and the evening performance, Elvis and his parents gave an extended audience. The dark blue shirt he wore was sewn by his mother Gladys. The performance was not without some nostalgia: as a ten-year-old, Elvis had entered a children's talent show at the same fair, winning second prize for singing Old Shep—five dollars in cash and free rides for the whole day.

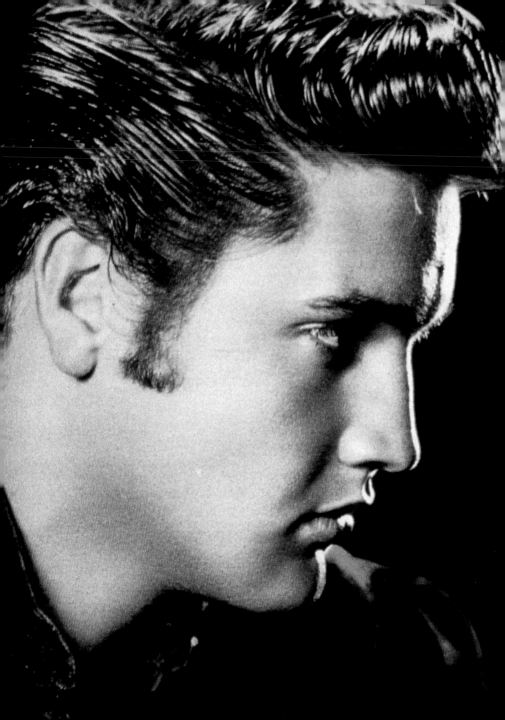

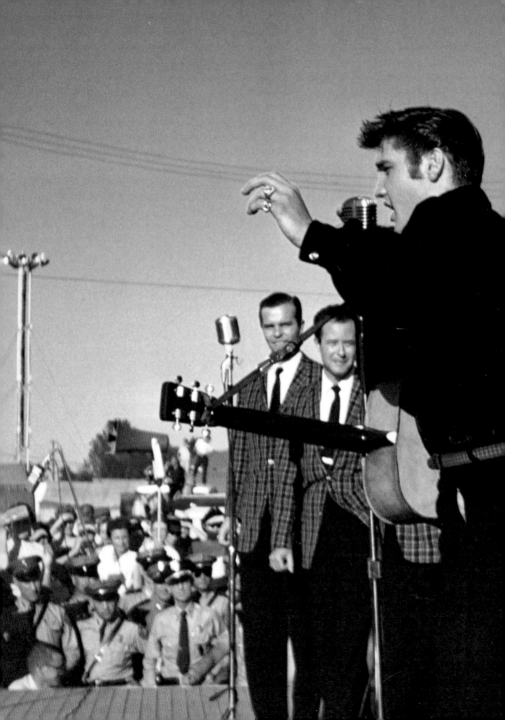

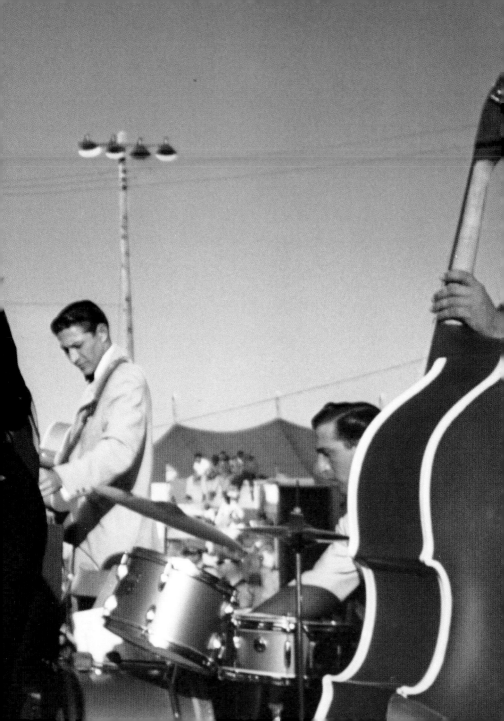

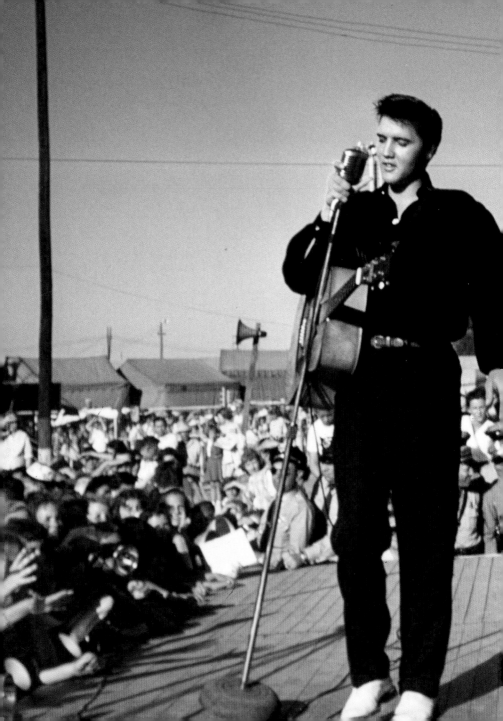

Right and following pages: "Louisiana Hayride" was a radio show for country music broadcast every Saturday evening from eight to eleven on KWKH live from the Shreveport Municipal Auditorium. The show was usually carried by more than 190 radio stations in the South. Between October 16, 1954, and December 16, 1956, Elvis made fifty appearances on the show. For the premiere performance he sang his first hits That's All Right (Mama) *and* Blue Moon of Kentucky. *These two photos show Elvis at his last appearance on the show, a benefit concert for the YMCA in Shreveport on December 16, 1956. In the background is drummer D. J. Fontana, a regular member of Elvis's backing group.*

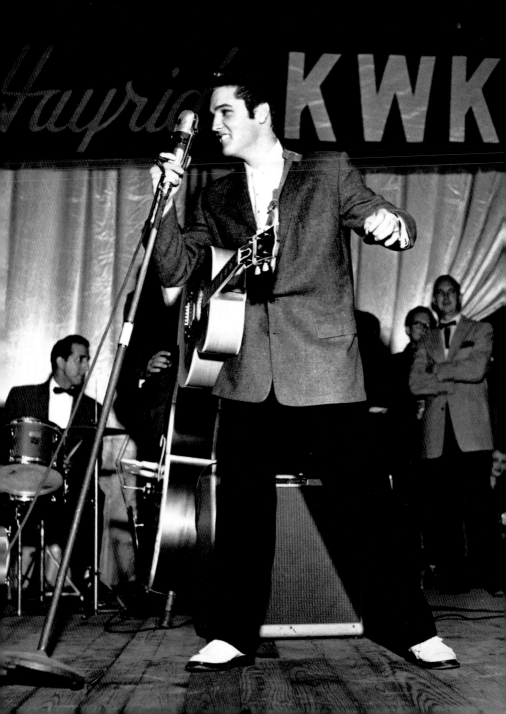

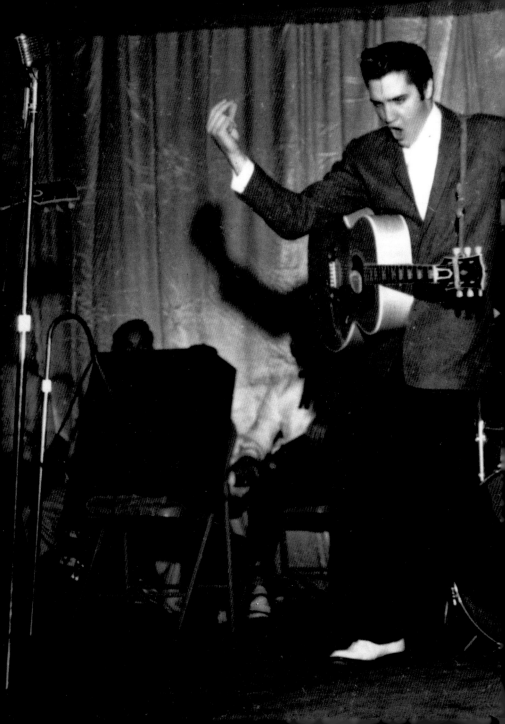

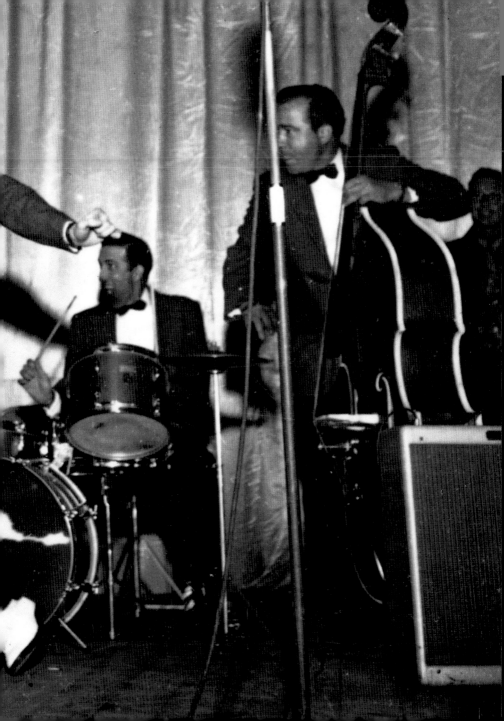

Up until the moment that Hollywood, in the form of producer Hal B. Wallis and his team, began to shape his image, Elvis bore sole responsibility for his artistic appearance. The music, the arrangements, his hairstyle, the choice of clothing and the choreography of his performances—he chose everything himself, inventing or synthesizing it from the most diverse elements. In spring 1956 Elvis Presley was a "King" in his own right and entirely to his own taste. But the intrusion of Hollywood led to the rough diamond being polished into an industrial product; he was successfully given a more refinded exterior, but the long-term effect was one of artistic loss. The army was later to finish the job.

"When I ran the test I felt the same thrill I experienced when I first saw Errol Flynn on the screen . . . The camera caressed him." Film producer Hal B. Wallis on Elvis's cinematic aura.

Right: Publicity photo for the film Jailhouse Rock.

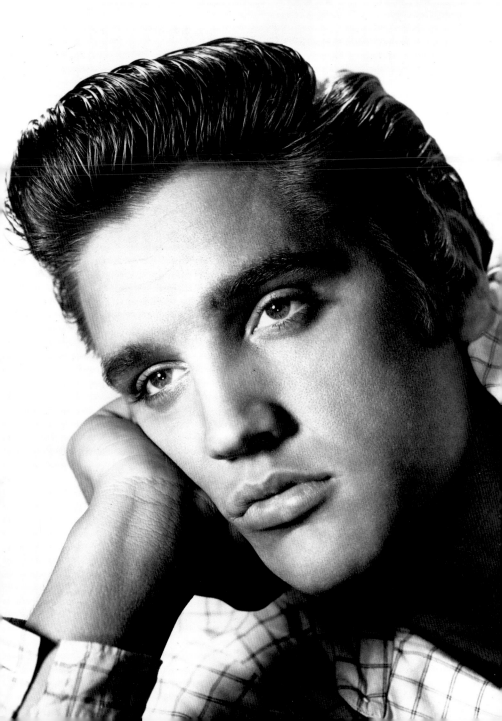

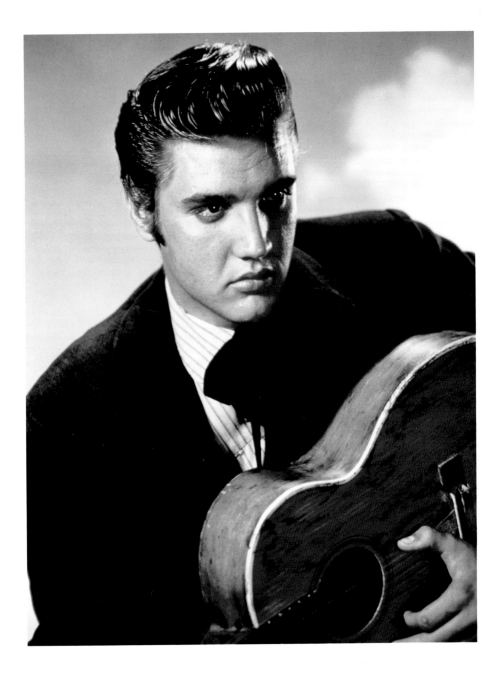

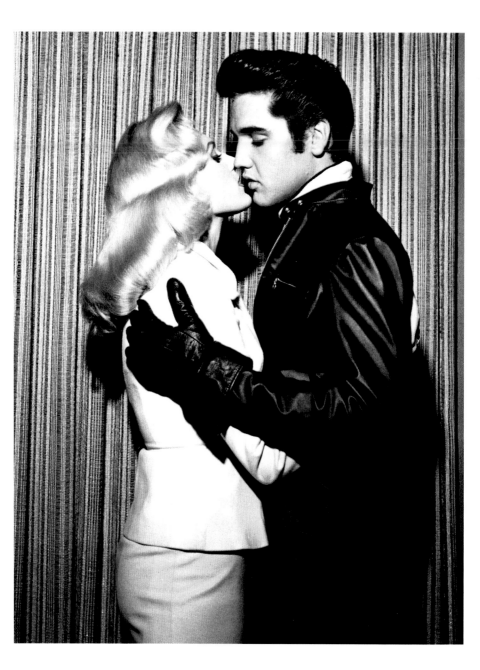

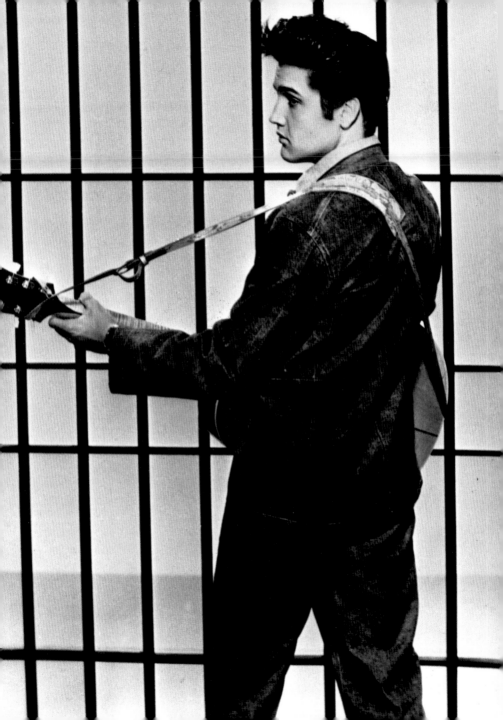

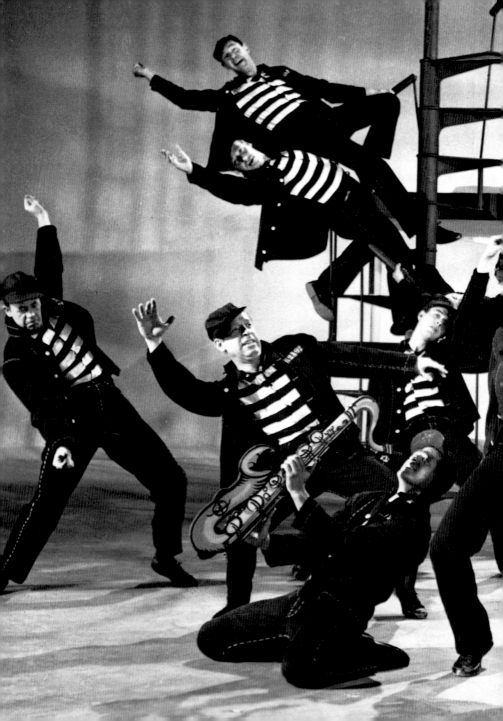

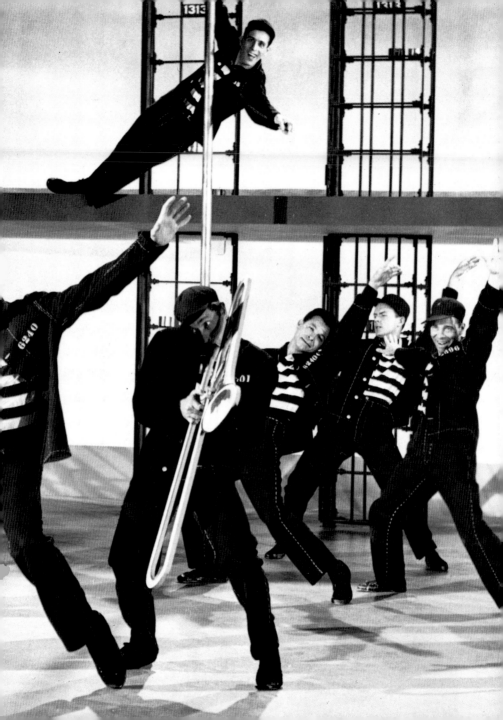

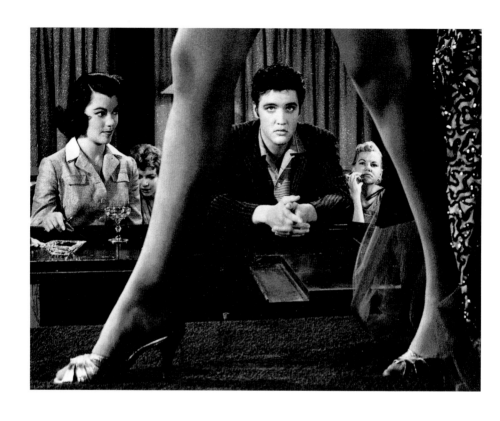

Above and right: Still photos from Jailhouse Rock. *In black trousers and dark sweater—the famous "Baby, I Don't Care" sweater—Elvis sings* Baby, I Don't Care *at a poolside party.*

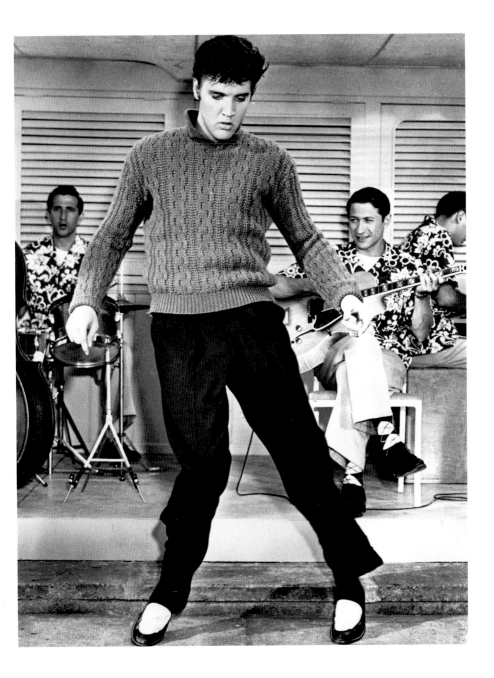

Elvis practicing the songs from Jailhouse Rock *in the MGM recording studio in Hollywood, 1957.*

74

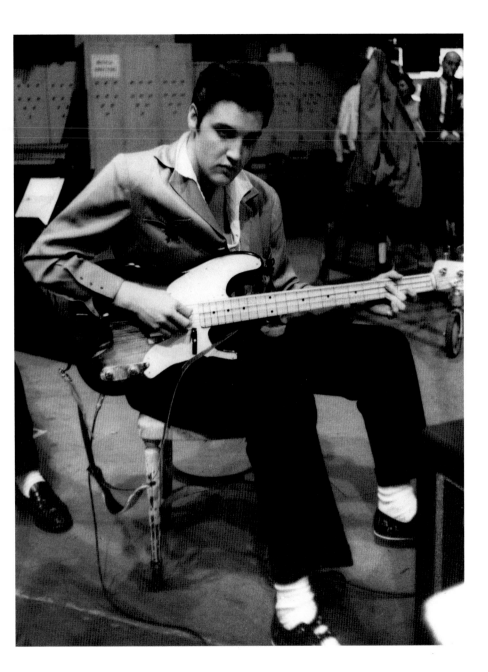

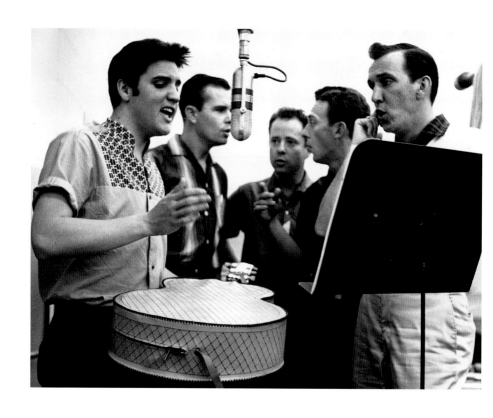

Above and right: A total of seven songs were recorded for Jailhouse Rock. *The photo above shows Elvis with the Jordanaires, a gospel and country quartet that did the backing vocals for Elvis from* Hound Dog *and* Don't Be Cruel *(in July 1956) on. Right: Elvis with drummer D. J. Fontana.*

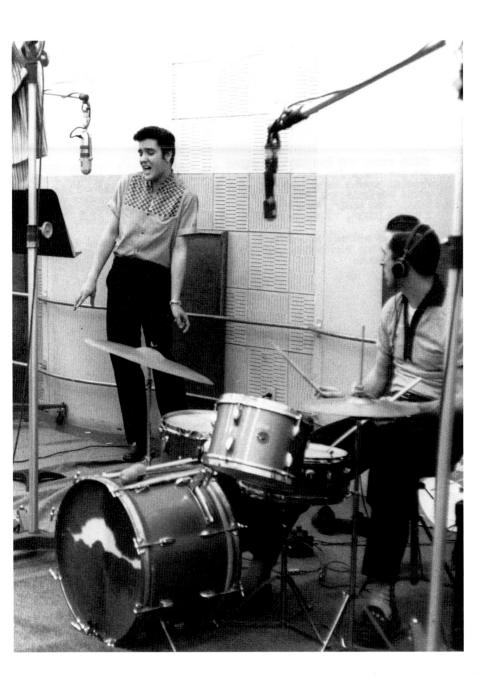

Right: Elvis as "Golden Boy," an icon of the Elvis cult, with reminiscences of Pharaoh Tutankhamen.

Following pages: Elvis during a concert in Vancouver on August 31, 1957. The jacket of the famous golden suit he is wearing signalizes his newly achieved wealth—Elvis has become a millionaire.

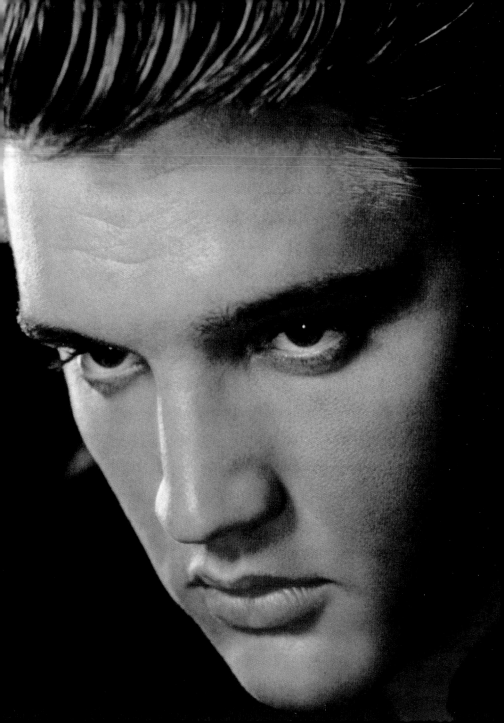

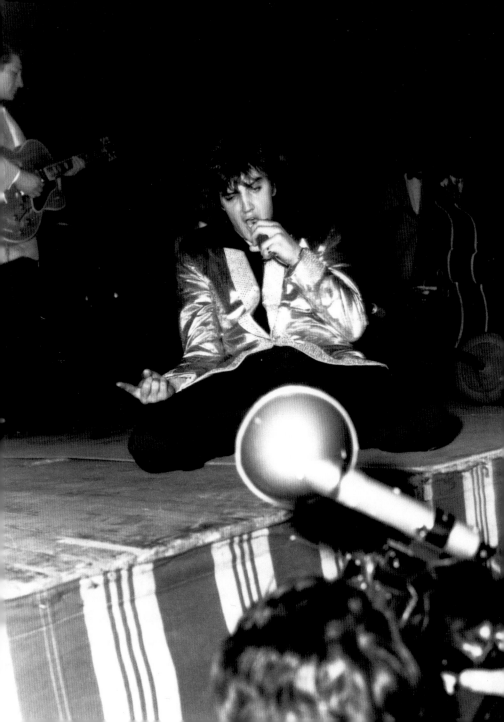

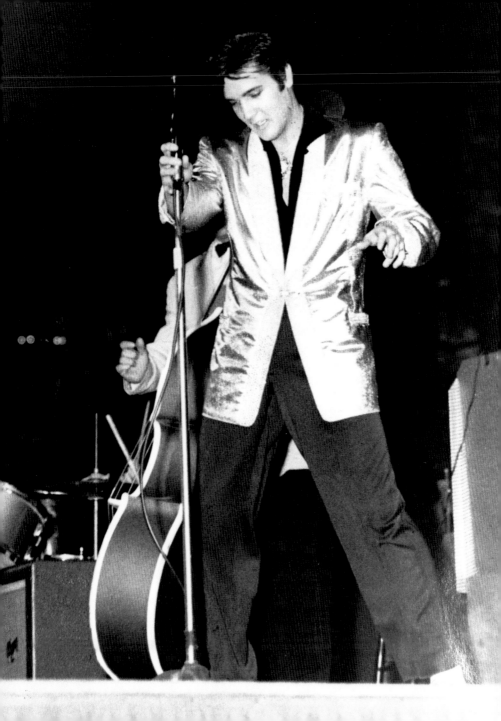

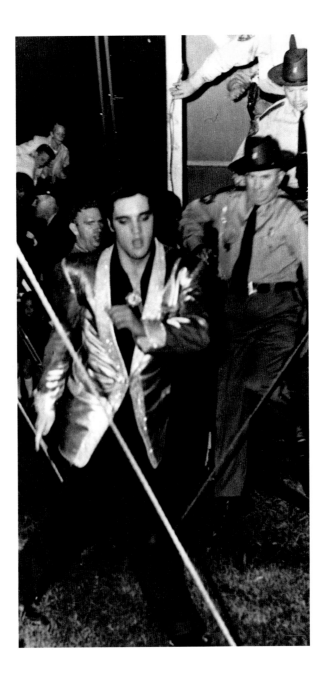

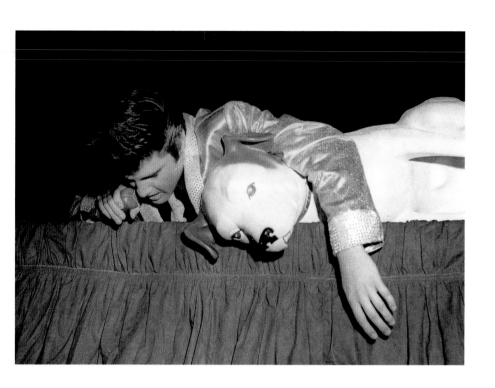

Left: In 1957 Elvis gave another concert in his home town, Tupelo. After the last bar of Hound Dog *he had to leave the stage under police escort—twelve thousand fans went completely berserk.*

Above: Elvis embracing the RCA mascot, Nipper, the partner he often used when he sang Hound Dog.

Elvis in the famous gold lamé tuxedo created for him by Hollywood designer Nudie Cohen. This extravagant suit, estimated to be worth $10,000, was no doubt meant to show that Elvis had arrived. It suggested a King Midas touch which the press was glad to pick up on.

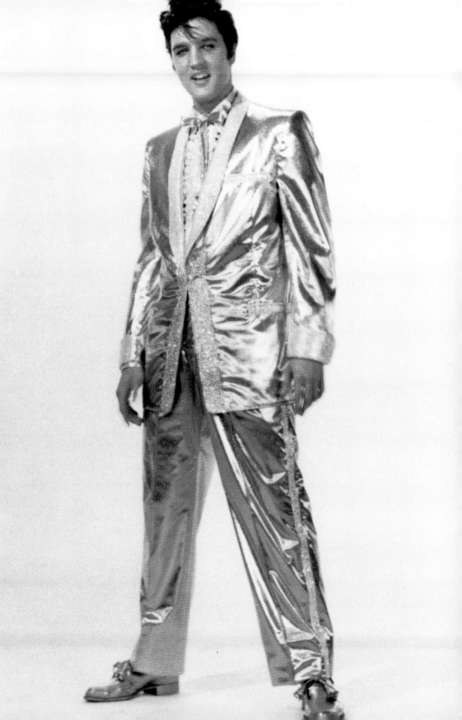

In March 1957, Elvis purchased the Graceland estate in Memphis. The address today is: 3764 Elvis Presley Boulevard, Memphis, Tennessee 38116.

The Colonial house is located on a hill surrounded by fourteen acres of land with a stand of mature trees, a barn and a tennis court. The estate is enclosed by an eight-foot-high brick wall. The main entrance is a large iron gate with musical insignia. The house was built of tan Tennessee limestone and contained twenty-three rooms including five bedrooms. After a spacious entry hall, the front part of the luxuriously appointed house comprises the living, dining and music rooms. Along the walls are large, white sofas. The focus of attention is the gilded concert grand piano. The curtains are white interlaced with gold thread. The shag rug is so thick that your shoes nearly disappear. At the back of the house are the recreation rooms, covering nearly the entire length of the house and about half of its breadth. The billiard room is dominated by a large pool table. The trophy room contains Elvis's gold and platinum records. Upstairs is the bedroom suite and the guest rooms. The bedroom: navy-blue shag run, oversized white bed with built-in telephone, intercom, TV controls. After the bedroom come the study and the mirror-lined bath. Sixteen televisions are found throughout the house.

Since June 7, 1982, Graceland has been open to the public for an admission fee ($16.00: April 1993). An average of 2,500 visit the house every day.

The young home owner in front of the estate that he lived in with his parents and family until his death.

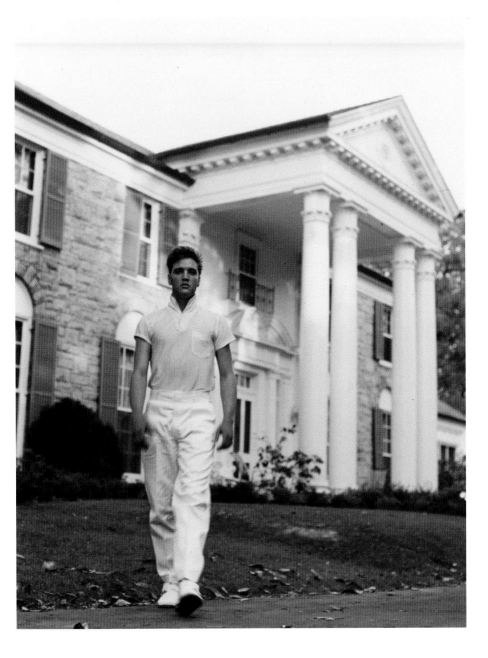

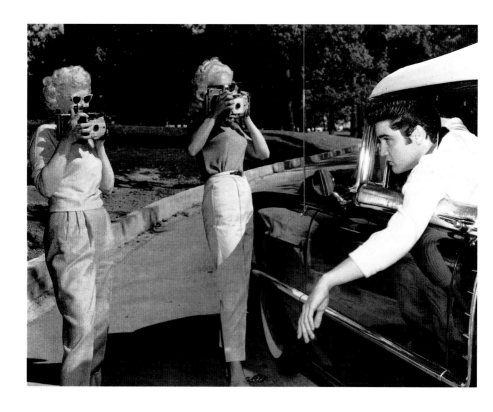

Two attractive blondes photographing Elvis in the Graceland driveway, ca. 1958.

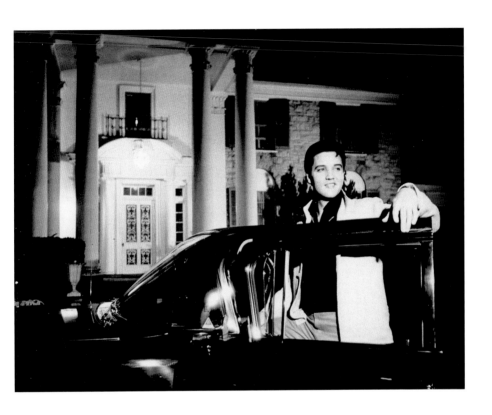

Elvis at the entrance to his illuminated mansion.

Elvis's fourth film is *King Creole*. Before shooting is completed, Elvis is drafted into the U.S. Army. He manages to get a sixty-day deferment to complete the film. On March 24, 1958 he reports for duty.

Right: Publicity photo for King Creole, *which opened nationally on July 2, 1958.*

Following pages: Film stills from King Creole; *Elvis in the role of Danny Fisher.*

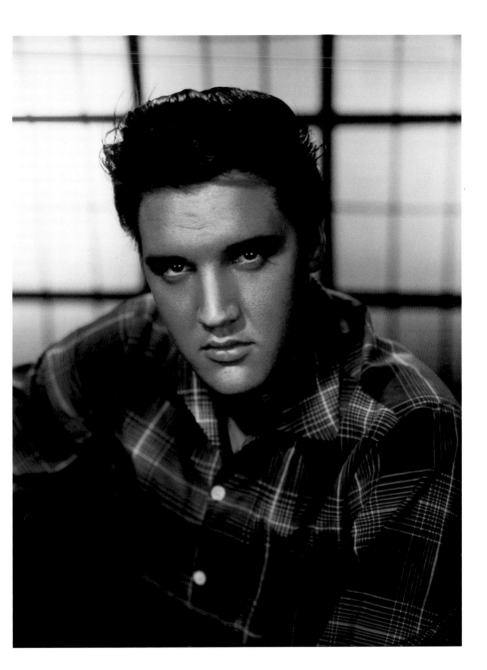

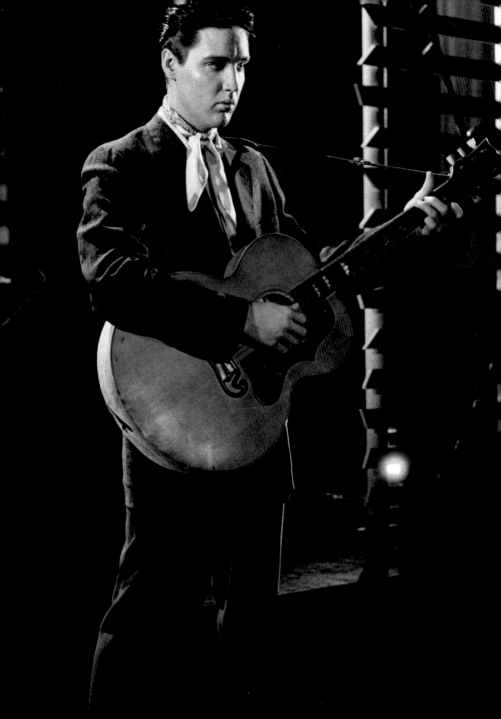

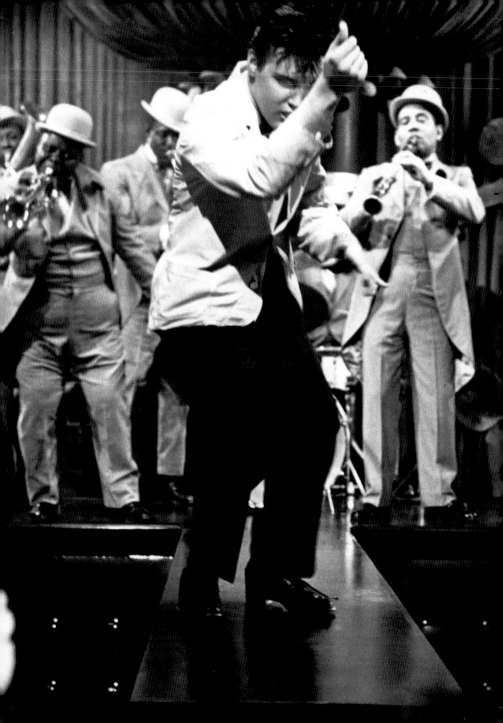

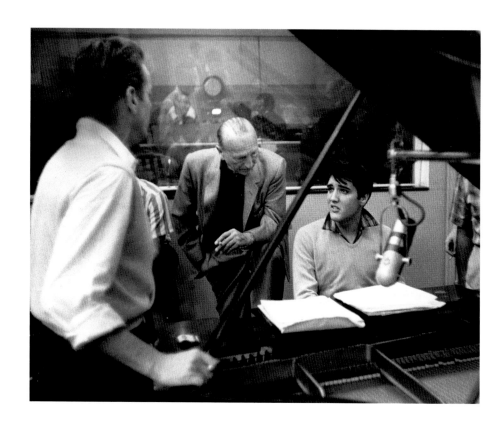

In the studio, recording songs for King Creole. *Above: with the director of the film, Michael Curtiz, who had already made Hollywood history in 1942 with* Casablanca.

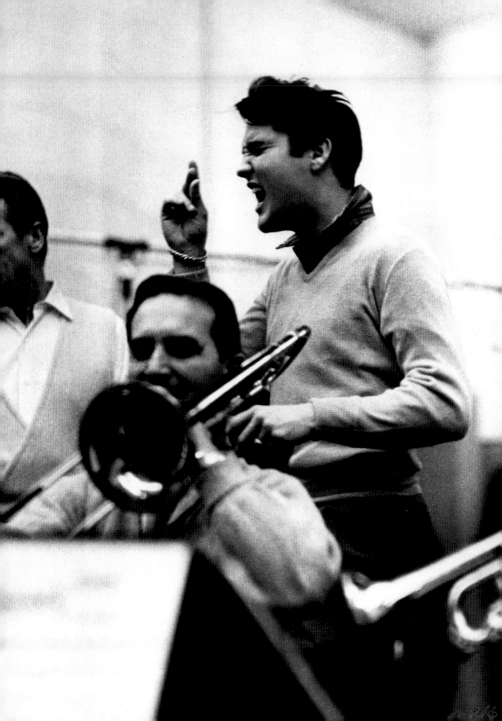

Elvis is drafted into the army on March 24, 1958 (US 53310761). About five hundred, mostly female, fans make a screaming protest in front of Kennedy Veterans Hospital, the official army draft center. On the same day Elvis is carried off in a green army bus—escorted by his fans in a long auto procession—to Fort Chaffee, Arkansas. After about two weeks he is assigned to the Second Armored Division and transferred to Fort Hood, Texas for basic training. His monthly earnings of $400,000 as a civilian shrink to $78 as a G.I. Colonel Tom Parker intervenes with Lt. General William H. Arnold, Commander of the Fifth Army, to prevent Elvis from receiving special treatment by being admitted to the Special Services. After basic training Elvis is stationed with the U.S. Army in West Germany. Before his departure, his mother suddenly dies on August 14, 1958 at forty-six as a result of hepatitis.

A pensive Elvis aboard the troop carrier General Randall *as it leaves Brooklyn Harbor on September 22, 1958 to the accompaniment of* All Shook Up *played by a military band. The destination is Bremerhaven, Germany.*

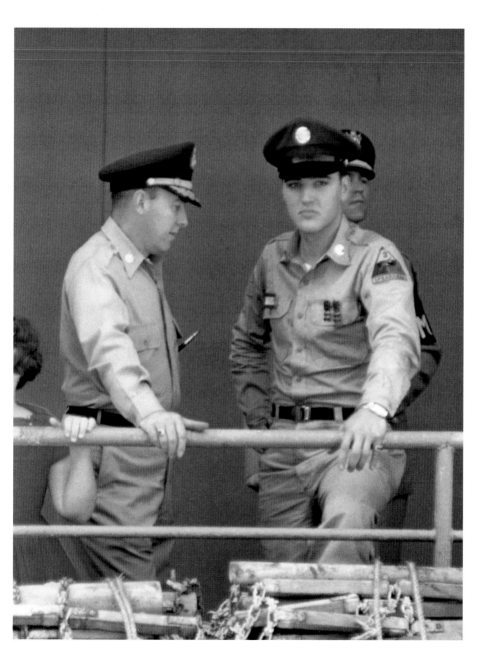

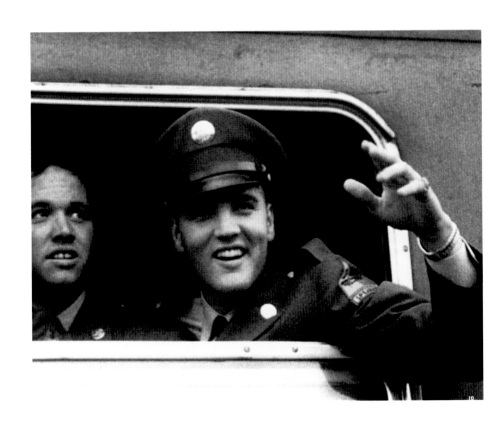

Above and right: As the General Randall *docks at the Columbus Quay in Bremerhaven on October 1, 1958, Elvis receives a boisterous reception by a crowd of German fans. They also give an enthusiastic send-off to the military train that takes Elvis and his comrades to the U.S. base at Friedberg, a town north of Frankfurt where Elvis is stationed for the remainder of his military career.*

Following pages: Elvis on arrival at Ray Barracks in Friedberg, 1958.

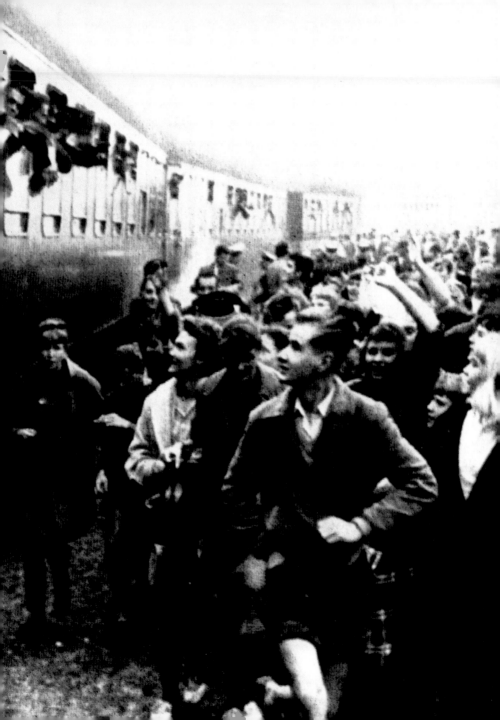

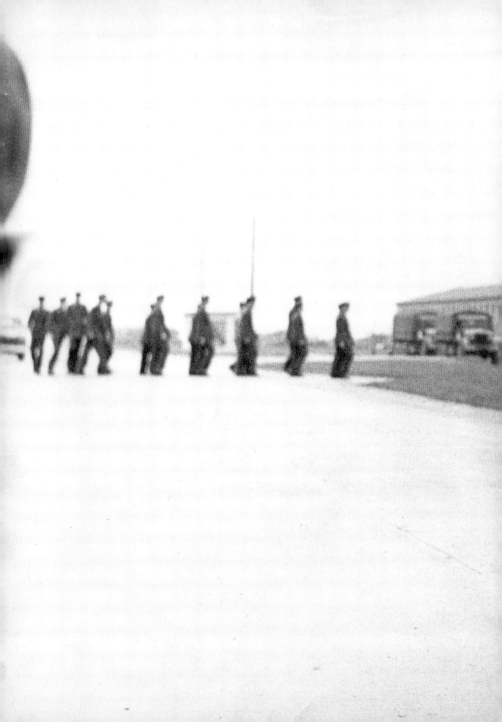

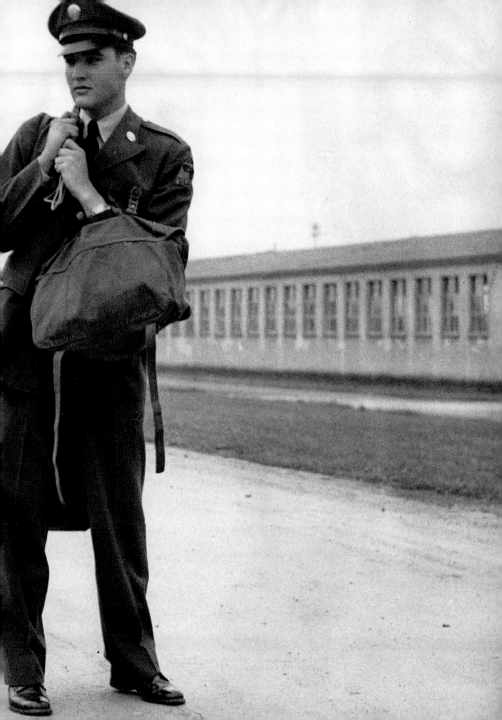

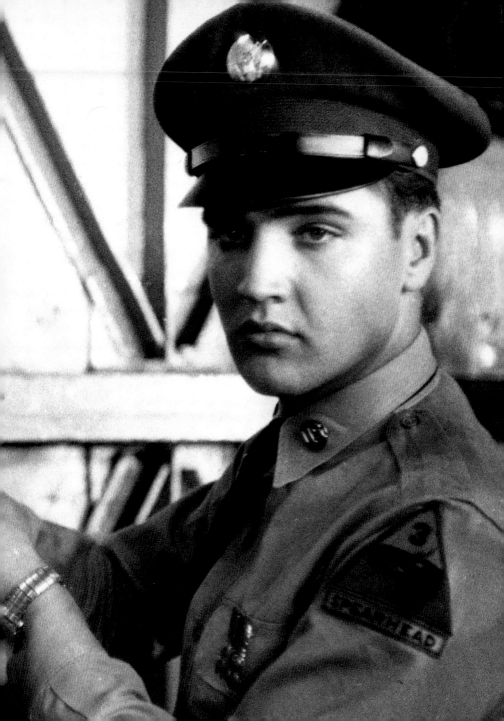

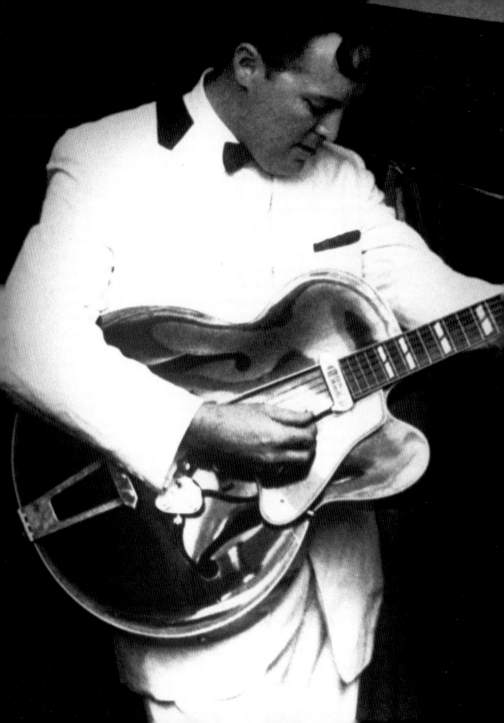

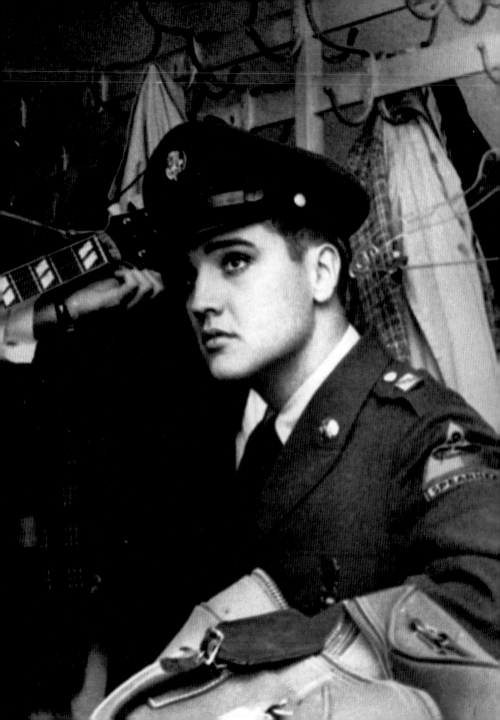

During Elvis's stint in the army, his fans are not deprived of their new Elvis Presley hits. Recorded prior to his drafting, the following songs are released during his military service: *Wear My Ring Around Your Neck / Doncha' Think It's Time* (April 1958); *Hard Headed Woman / Don't Ask Me Why* (June 1958); *I Got Stung / One Night* (October 1958); *(Now and Then There's) A Fool Such as I / I Need Your Love Tonight* (March 1959); *A Big Hunk o' Love / My Wish Came True* (July 1959).

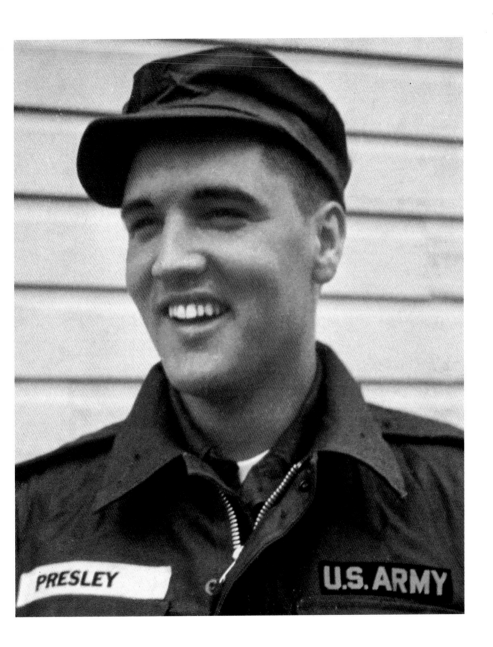

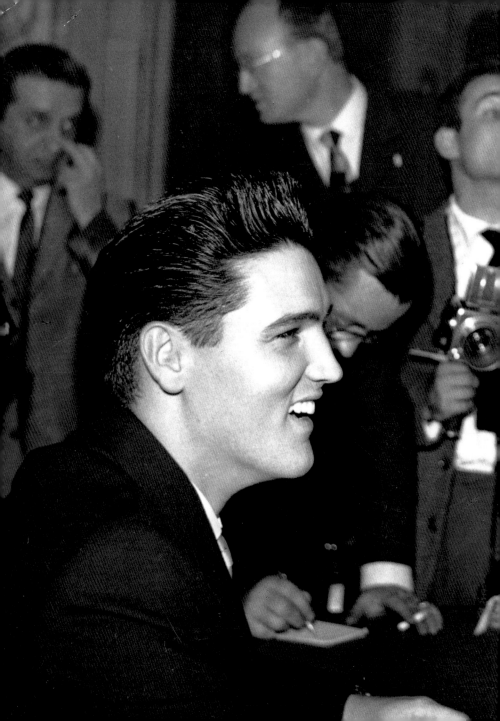

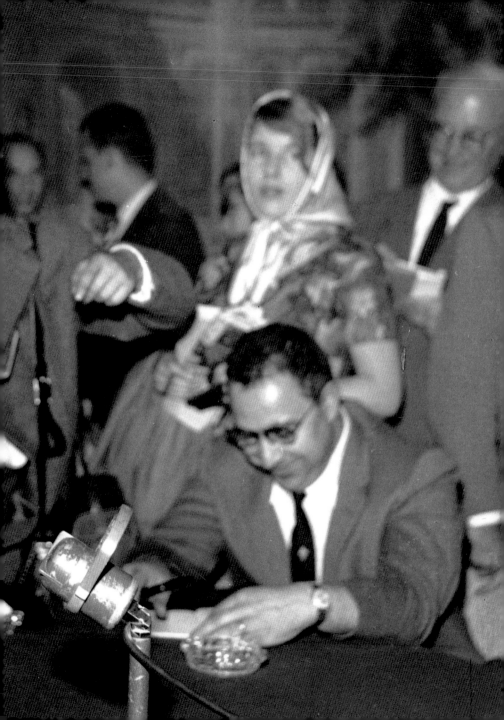

Elvis comes out of the army noticeably changed. The music scene has also been radically transformed. A sign of the times is that Elvis Presley's hit *It's Now or Never,* an American version of the Neapolitan song *O sole mio,* cedes its number-one position on the U.S. charts to Chubby Checkers' *The Twist.* A new era is on the way, the Beatles are knocking at the door, and the King capitulates after his last live concert on March 25, 1961 in Honolulu. Not until late 1968 does he risk a comeback.

Right: Hollywood gossip columnist Hedda Hopper described Elvis's change in the early sixties: "He's the best mannered star in Hollywood and he's improved as a performer and has a determination be a fine actor. He was smart enough to simmer down that torrid act of his." In light of the creative decline evident in the lightweight film career Elvis embarked on, John Lennon's comment is more realistic: "Elvis died when he went into the army."

Chronology

1935 Elvis Aaron Presley is born in the small, northeastern Mississippi town of Tupelo as the son of the casual laborer Vernon Elvis Presley and his wife Gladys. His still-born twin brother, Jesse Garon, is buried by his parents one day later at the Priceville Cemetery northeast of Tupelo.

1941 Elvis starts school in September at the East Tupelo Consolidated School.

1945 Elvis wins second prize at a talent show at the Mississippi-Alabama Fair and Dairy Show on October 3.

1946 His parents give him a guitar worth $7.75. Elvis practices on this instrument for years – with at first only modest success. In the autumn he begins attending Milam Junior High School in Tupelo.

1948 Like many others at the time, the Presleys migrate to the city. On September 12 they arrive in Memphis and move into a one-bedroom apartment. The family is very poor and qualifies for financial assistance.

1949 The Presleys move into a two-bedroom apartment. Elvis attends L. C. Humes High School, where he graduates in 1953. Elvis takes part-time, mostly evening jobs as an usher at a movie theater and at a metal factory.

1953 On April 9, Elvis appears at the Humes High Annual Minstrel Show. His performance gets the most applause. In July, he starts working at Crown Electric as a truck driver. Late in the summer on a Saturday afternoon, Elvis goes to the Memphis Recording Studio and records, at his own expense, his first single: *My Happiness* and *That's When Your Heartaches Begin*. He gives his mother the recording for her birthday.

1954 In early June, Elvis Presley makes his first official single for Sun Records: *That's All Right (Mama) / Blue Moon of Kentucky*. July 30: First concert at the Overton Park Shell in Memphis. Numerous rural engagements.

1955 February 14: Colonel Thomas Andrew Parker, a successful manager in entertainment, takes on Elvis as a client. His clever management skyrockets Elvis Presley to King of Rock 'n' Roll. Elvis switches from Sun Records to RCA.

1956 In January Elvis records his first international hit: *Heartbreak Hotel*. His

national television début follows on January 28 on the Dorsey Brothers' "Stage Show." On March 15 Colonel Parker becomes Elvis's official manager. September 9: sensational TV appearance on "The Ed Sullivan Show." On November 15, *Love Me Tender,* his second international hit, is released.

1957 On February 15 RCA announces that Elvis Presley has sold his eight millionth record. In March he purchases the Graceland estate in Memphis. October 17: Premiere of *Jailhouse Rock.* On December 26 Elvis donates a truck full of teddy bears to the National Foundation for Infantile Paralysis.

1958 Elvis is drafted into the U.S. Army (US 53310761) and after basic training in Fort Hood, Texas, is transferred to Friedberg, Germany. On August 14 his mother Gladys dies. In Germany he meets the stepdaughter of Air Force Captain Joseph Beaulieu, Priscilla Ann (born May 25, 1945).

1960 Elvis leaves Germany on March 2. Three days later he receives his discharge from the army at Fort Dix. On July 3, his father marries Davada (Dee) Stanley in Huntsville, Alabama.

1961 On February 25 (Ellis Auditorium, Memphis) and March 25 (Bloch Arena, Pearl Harbor, Hawaii) Elvis Presley gives important live concerts, his last until 1969.

1962 Dick Clark dedicates his "American Bandstand" program on January 8 to the King on the occasion of his twenty-seventh birthday.

1963 *Love Me Tender* is the first Elvis Presley film to be shown on television (December 11).

1964 On January 30 Elvis buys Franklin D. Roosevelt's former presidential yacht "Potomac" and donates it to St. Jude's Children's Hospital.

1965 On August 27 the Beatles visit Elvis at his house in Bel Air.

1967 May 1: Elvis and Priscilla Beaulieu are married at the Aladdin Hotel in Las Vegas. A second wedding reception is held on May 29 for friends and employees. On September 29, Elvis Presley Day is celebrated in Tennessee.

1968 Lisa Marie Presley is born on February 1. On December 3 Elvis makes his first public performance since 1961 on a television special entitled "Elvis."

1969 July 31 to August 31. First live appearance in eight years at the International Hotel, Las Vegas (57 shows). Elvis celebrates a phenomenal comeback.

1971 Elvis's birthplace in Tupelo, Mississippi, is opened to the public on June 1. On September 8 he receives the Bing Crosby Award.

1972 Elvis and Priscilla separate on February 23.

1973 October 9: divorce is granted. Rumors circulate of the King's illnesses. His weight problem is obvious.

1974 January 8: Governor Jimmy Carter proclaims Elvis Presley Day in Georgia.

1975 Elvis undergoes a face-lift at Mid-South Hospital in Memphis.

1976 Concert tours are frequently interrupted because of the star's exhaustion. Several times, photography is not allowed during the performances due to his poor appearance.

1977 May 29: Elvis leaves the stage for the first time during a concert in Baltimore, returning after thirty minutes. June 26: Elvis's last performance at the Market Square Arena in Indianapolis. On August 16, Elvis Presley is found dead in his bathroom in Graceland by his girlfriend, Ginger Alden. August 18: Elvis is buried next to his mother at Forest Hill Cemetery. On October 2, the bodies of Elvis and his mother are moved to Graceland.

Discography of Singles 1954–1960

(Dated according to first release of the single, unless otherwise indicated)

1954 19 July: *That's All Right (Mama)* (Arthur Crudup) / *Blue Moon of Kentucky* (Bill Monroe)

25 September: *Good Rockin' Toonight* (Roy Brown) / *I Don't Care If the Sun Don't Shine* (Mack David)

1955 8 January: *Milkcow Blues Boogie* (James Arnold) / *You're a Heartbreaker* (Charles Alvin Sallee)

1 April: *Baby, Let's Play House* (Arthur Gunter) / *I'm Left, You're Right, She's Gone* (Stanley Kesler, Bill Taylor)

August: *Mystery Train* (Herman Parker, Sam Phillips) / *I Forgot to Remember to Forget* (Stanley Kesler, Charlie Feathers)

1956 27 January: *Heartbreak Hotel* (Tommy Durden) / *I Was the One* (Aaron Schroeder, Claude DeMetrius, Hal Blair, Bill Pepper)

May: *I Want You, I Need You, I Love You* (Maurice Mysels, Ira Kosloff) / *My Baby Left Me* (Arthur Crudup)

July: *Hound Dog* (Jerry Leiber, Mike Stoller) / *Don't Be Cruel* (Otis Blackwell)

3 September (recording date): *Ready Teddy* (John Marascalco) / flip side unrecorded (promotion single)

September: *Blue Suede Shoes* (Carl Perkins) / *Tutti Frutti* (Little Richard, Bumps Blackwell); *Blue Moon* (Richard Rodgers, Lorenz Hart) / *Just Because* (Bob Shelton, Joe Shelton, Sid Robin); *I Got a Woman* (Ray Charles) / *I'm Counting on You* (Don Robertson); *Tryin' to Get to You* (Rose Marie McCoy, Margie Singleton) / *I Love You Because* (Leon Payne); *I'll Never Let You Go (Little Darling)* (Jimmy Wakely) / *I'm Gonna Sit Right Down and Cry (Over You)* (Thomas and Howard Biggs); *Shake, Rattle and Roll* (Charles E. Calhoun, pseudonym of Jesse Stone) / *Lawdy Miss Clawdy* (Lloyd Price); *Money Honey* (Jesse Stone) / *One-Sided Love Affair* (Bill Campbell)

October: *Love Me Tender* (Ken Darby) / *Any Way You Want Me (That's How I Will Be)* (Aaron Schroeder, Cliff Owens)

December: *Old Shep* (Red Foley, Willis Arthur) / flip side unrecorded (promotion single)

1957 January: *Too Much* (Lee Rosenberg, Bernard Weinman)/*Playing for Keeps* (Stanley A. Kesler)

March: *All Shook Up* (Otis Blackwell)/*That's When Your Heartaches Begin* (William J. Raskin, Billy Hill, Fred Fisher)

June: *Teddy Bear* (Kal Mann, Bernie Lowe)/*Loving You* (Jerry Leiber, Mike Stoller)

September: *Jailhouse Rock* (Jerry Leiber, Mike Stoller)/*Treat Me Nice* (Jerry Leiber, Mike Stoller)

October: *Have I Told You Lately That I Love You* (Scott Wiseman)/*Mean Woman Blues* (Claude DeMetrius) (promotion single)

November: *Blue Christmas* (Billy Hayes, Jay Johnson)/*Blue Christmas* (Billy Hayes, Jay Johnson) (promotion single)

1958 January: *Don't* (Jerry Leiber, Mike Stoller)/*I Beg of You* (Rose Marie McCoy, Kelly Owens)

April: *Wear My Ring Around Your Neck* (Bert Carroll, Russell Moody) / *Doncha' Think It's Time* (Clyde Otis, Willie Dixon)

June: *Hard Headed Woman* (Claude DeMetrius)/*Don't Ask Me Why* (Fred Wise, Ben Weisman)

October: *I Got Stung* (Haron Schroeder, David Hill)/*One Night* (Dave Bartholomew, Pearl King)

1959 March: *(Now and Then There's) A Fool Such as I* (Bill Trader)/*I Need Your Love Tonight* (Sid Wayne, Bix Reichner)

July: *A Big Hunk o' Love* (Aaron Schroeder, Sid Wyche)/*My Wish Came True* (Ivory Joe Hunter)

1960 March: *Stuck on You* (Aaron Schroeder, J. Leslie McFarland)/*Fame and Fortune* (Fred Wise, Ben Weisman)

July: *It's Now or Never* (G. Capurro, Eduardo di Capua, Aaron Schroeder, Wally Gold)/*A Mess of Blues* (Doc Pomus, Mort Shuman)

November: *Are You Lonesome Tonight?* (Roy Turk, Lou Handman)/*I Gotta Know* (Paul Evans, Matt Williams)

Filmography 1956–1958

LOVE ME TENDER

Premiere: November 15, 1956

Lieutenant Vance Reno (Richard Egan) and his two brothers return home from the Civil War (1865) with the Union Army payroll they had robbed. Here a bitter disappointment awaits Vance: since he was presumed dead for two years, his wife had married his youngest brother, Clint (Elvis Presley). But the old love is rekindled. In the end, Clint, having cleared away all points of contention, is mortally wounded. His last words: "Everything's gonna be all right."

We're Gonna Move—sung on the Renos' front porch; *Love Me Tender* follows immediately after and is repeated at the end of the film; *Let Me*—Elvis at a town meeting to build a new school house; *Poor Boy* follows right after *Let Me*. In addition, a Union soldier plays *Beautiful Dreamer* on a harmonica at the Greenwood railway station.

LOVING YOU

Premiere: July 9, 1957

The young truck driver Deke Rivers (Elvis Presley) is discovered as a singer by press agent Glenda Markle (Lizabeth Scott) and contracted to play in a band. As his success mounts, he has to decide between Glenda and the singer in the band, Susan Jessup (Dolores Hart). *Loving You* is Elvis's first color film.

Got a Lot o' Livin' to Do—Elvis with Tex Warner's band in Delville. Later the song is heard as a medley with *Teddy Bear* and *Hot Dog* from a jukebox during a fight and on stage in Freegate, Texas; *(Let's Have a) Party*—sung on stage in Longhorn, Texas and in other towns on the tour; *(Let Me Be Your) Teddy Bear*—sung in a medley with the first song and with *Hot Dog*. Later in concert at the Grand Theater, Amarillo: *Hot Dog*—sung in a medley with the previous song and *Got a' Lot o' Livin' to Do*. Later live in Towanda: *Lonesome Cowboy*—live on stage in Rodeo City; *Mean Woman Blues*—Elvis sings this song in Buckhorn Tavern, accompanied by the jukebox; *Loving You*—the title song is sung by Elvis at the Jessup Farm and later in Freegate Civic Auditorium; Dolores Hart also sings *Dancing on a Dare, Detour* and *The Yellow Rose;* Tex Warner's "Rough Ridin' Ramblers" play *Candy Kisses.*

JAILHOUSE ROCK

Premiere: October 17, 1957

The quick-tempered truck driver, Vince Everett (Elvis Presley), is jailed on a manslaughter charge after a brawl. His cell-mate, former crooner Hunk Houghton (Mickey Shaughnessy), helps Vince get started as a singer after his release. Success finally comes with the help of Peggy Van Alden (Judy Tyler), a promoter who launches her own record company with Vince. This leads to conflict with Hunk.

Young and Beautiful—Elvis sings this song in the prison cell. It is repeated later in Club La Florita and at the end of the film; *I Want to Be Free*—understandable wish of inmate Vince Everett, sung on the television show "Breath of a Nation"; *Don't Leave Me Now*—sung twice in a recording studio; *Treat Me Nice*—also performed in a recording studio; *Jailhouse Rock*—Elvis sings the title song during a rehearsal for an NBC TV special; *(You're So Square) Baby, I Don't Care*—sung by Elvis at a poolside party; *One More Day* is sung by Mickey Shaughnessy at the beginning of the film.

KING CREOLE

Nationwide opening on July 2, 1958

Danny Fisher (Elvis Presley), penniless a high-school dropout, earns money by sweeping floors at the Blue Shade nightclub. He also joins a youth gang and beats its leader, Shark (Vic Morrow) in a fistfight. In the King Creole nightclub, Danny is given his chance as a singer. With his growing success, he becomes involved in intrigues and fistfights that lead to his tragic end. The director was Michael Curtiz, best known for cult films such as *Casablanca* (1942).

Crawfish—duet with a street vendor (Kitty White) on a balcony; *Steadfast, Loyal and True*—sung at the Gilded Cage nightclub; *Lover Doll*—Elvis causes a distraction singing this song in a department store while Shark, Sal and Dummy are busy stealing the merchandise; *Trouble*—sung live at the Gilded Cage; *Dixieland Rock*—live at King Creole; *Young Dreams*—live at King Creole; *New Orleans*—live at King Creole; *Hard Headed Woman*—live at King Creole; *King Creole*—the title song sung right after the preceding number; *Don't Ask Me Why*—live in King Creole; *As Long as I Have You*—the finale of the film sung live in King Creole; *Turtles, Berries and Gumbo* is sung by three black street vendors; *Banana* is sung by Liliane Montevecchi.

Select Bibliography

Doll, Susan. *Elvis: A Tribute to His Life.* London: Omnibus Press, 1990.

Goldmann, Albert (Harry). *Elvis.* New York: McGraw-Hill, 1981.

Haining, Peter, ed. *Elvis in Private.* New York: St. Martin's Press, 1987.

Hopkins, Jerry. *Elvis: A Biography.* New York: Simon and Schuster, 1971.

Hopkins, Jerry. *Elvis: The Final Years.* New York: St. Martin's Press, 1980.

Lichter, Paul. *Elvis in Hollywood.* New York: Simon and Schuster, 1975.

Marcus, Greil. *Mystery Train: Images of America in Rock 'n' Roll Music.* New York: E. P. Dutton, 1975.

Marsh, Dave. *Elvis.* New York: Thunder's Mouth Press, 1992.

Nelson, Pete. *King! When Elvis Rocked the World.* Los Angeles: Proteus, 1985.

Presley, Priscilla with Sandra Harmon. *Elvis and Me.* New York: Putnam's, 1985.

Stern, Jane and Michael. *Elvis World.* New York: Alfred A. Knopf, 1987.

Tharpe, Jac L., ed. *Elvis: Images and Fancies.* Jackson, Miss.: University Press of Mississippi, 1981.

Worth, Fred L. and Steve D. Tamerius. *Elvis: His Life from A to Z.* London: Corgi Books, 1989.

Photo Credits